Immerse yourself in nature and rewild your creative practice with inspiration from textile artist Jeanette Appleton. With a focus on the versatile mediums of felt and embroidery, she takes readers through a series of inspiring ideas for working with nature.

Learn how to recreate sea waves, puddles, hedge and grass in textiles. Discover a variety of strategies for overcoming artist's block, from changing the routes and patterns of your local environment to meditative contemplation to revisiting past diaries and sketchbooks. This book teaches us how to transform recycled cloth by bonding memories, mixed-media and found objects into work. It demystifies cutting and repairing techniques: making cuts and slits in the layers of fabric to reveal the secret strata of nature. Find out how to make the best use of sketchbooks, maps, and the power of using words from poetry, literature and your own personal life within your work.

Richly illustrated with exciting examples of the author's beautiful and reflective work, this inspirational and practical guide will appeal to textile and felt artists of all levels.

Textile
Creativity
Through
Nature

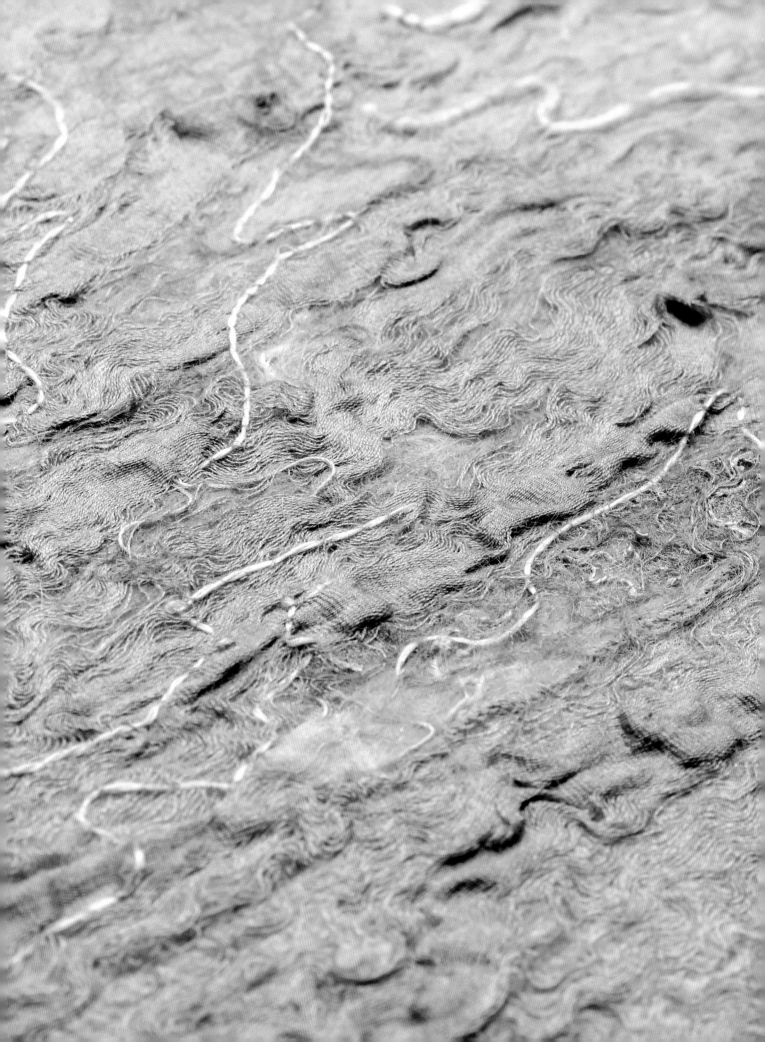

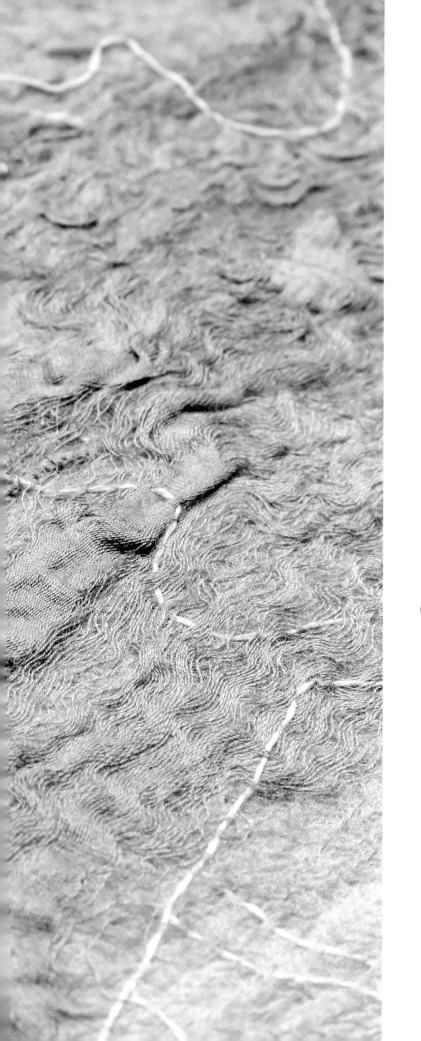

Textile Creativity Through Nature

Jeanette Appleton

BATSFORD

First published in the United Kingdom in 2023 by
B.T. Batsford Ltd
43 Great Ormond Street
London WC1N 3HZ
An imprint of B.T. Batsford Holdings Ltd

ISBN 9781849947732

A CIP catalogue record for this book is available from the British Library.

30 29 28 27 26 25 24 23
10 9 8 7 6 5 4 3 2 1

Reproduction by Rival Colour Ltd, UK
Printed by Toppan Leefung Ltd, China

This book can be ordered direct from the publisher at www.batsford.com

Page 1: Twisting plant threads.
Page 2: Changing Currents:
Challenging Changes, *detail
(see also page 42). Reconfigured
work with surface stitch.*
Above: Lace leaf.
Opposite: Grass felted by wind.

Contents

Foreword 6

Introduction 10

Chapter 1: Which Way? Maps and Sketchbooks 14

Chapter 2: Stitching Over the Past 28

Chapter 3: Bonding Memories 56

Chapter 4: Cutting and Repairing 64

Chapter 5: Words as Inspiration 78

Chapter 6: Gathering the Research 88

Chapter 7: Essence 98

Conclusion 120

Sources and bibliography 124

Suppliers 125

Index 126

Acknowledgements 128

Foreword

'The further one travels, the less one knows.'

From 'The Inner Light', George Harrison, English musician

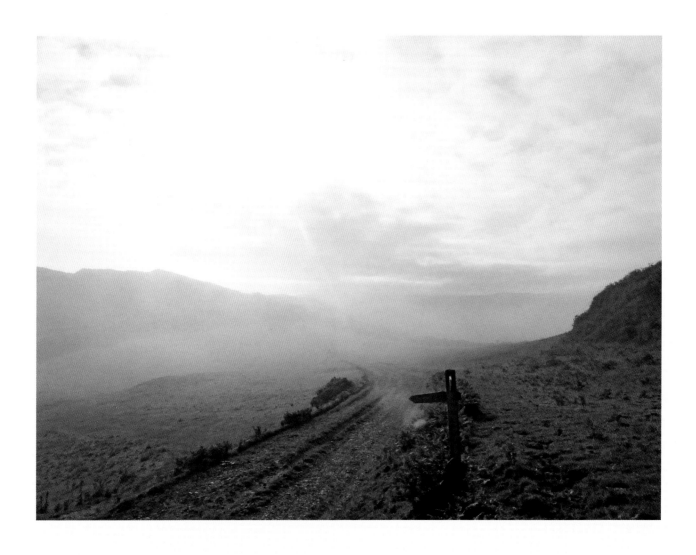

As the world stopped in spring 2020, the pandemic caused us all to reconfigure our lives in unexpected ways, changing from safe, known routines to coping with restrictions and uncertainty. *The Guardian* newspaper carried the headline 'Britain Shuts Down' as I crossed out my usual routine for over 20 years: travel for international projects, teaching, meeting friends and exploring new cities and galleries. I was suddenly marooned in a quiet North Devon coastal town wondering how I would cope with the lack of choice and a journey that now entailed only one daily walk.

Which way? To discover the footpaths surrounding my flat, to find a way to occupy my mind and a way out of a creative lockdown, I began with sorting the past 30 years of photographs, sketchbooks and folders of research of my textile practice into chronological order. This substantial timeline of the past consoled and grounded my unsettled emotions; I thought, whatever happens from now on may not validate my existence, but at least the past has.

The archive revealed forgotten projects, one of which was a sketchbook from 1995 for my first residency in Wales with 'which way?' written on the first page and an appropriate quote by the French artist and poet Jean Tardieu:

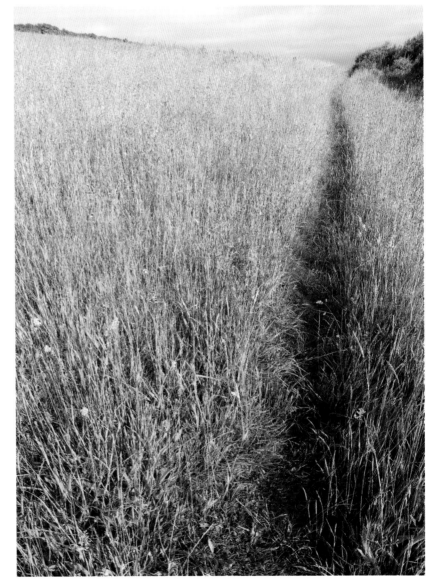

'In order to advance, I walk the treadmill of myself but with no more boundaries.'

This directed me to repeat the process in the current day, to treat this vacant time as a residency. I considered my daily walk as work, used to explore and document the surrounding environment, giving me a positive purpose and focus during the start of lockdown.

Opposite: Which way? Signpost on headland.

Right: No more boundaries – path through meadow.

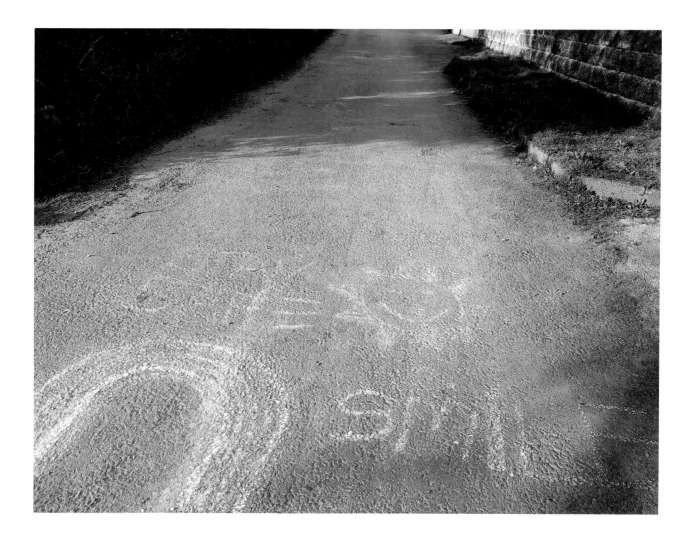

I was accustomed to collecting cultural contrasts as I travelled through countries and cities to share my textile skills, backpacking and staying with kind hosts, meeting extraordinary people. But I was never as alone as I was now, and I had to tune into a new way of looking at and engaging with the local environment. I was living in a very safe part of the country and found myself walking through an amazing biosphere of nature.

A surprising social life began involving brief exchanges with dog walkers, but I seemed to be the only walker without a dog!

Every day revealed uplifting surprises, whether from human activities in the town or nature's seasonal changes. On my first walk, I stepped over a rainbow chalked on the road telling me 'Stay safe – smile.' I found other messages on pebbles lining a path to the beach: 'You are not alone', 'You are loved' and 'Stay strong'. These words of kindness and support from invisible strangers gave me reassurance during the initial uncertainty of Covid.

Above: Rainbow drawn on the road.

Opposite: Pebbles on the path to the beach and various messages.

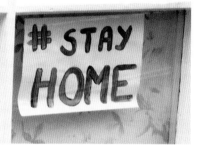

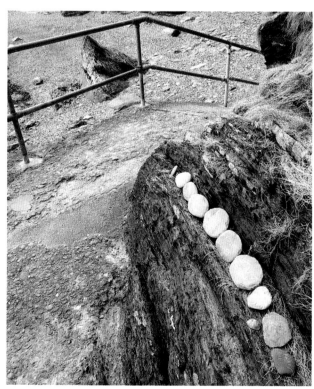

Introduction

‘*Instructions for living a life: Pay attention.*
Be astonished. Tell about it.’

From ‘Sometimes’, Mary Oliver, American poet

My aim in this book is to share the methods I discovered during the pandemic to recover from a complete creative block in my textile practice. My work had always reflected a life of travel through contrasting environments, using the felting technique because of its direct links with nomads and land. But this no longer applied to the restricted movements in one place with just my own observations to inspire me. I had never had the opportunity to record a repeated journey with no planned schedule, as previous distance and time was measured by planned flights and accommodation. Now the journey was determined by the exposed physical limits of my body and the weather.

The restricted lifestyle was so different that I found new areas of my imagination emerging. Words would drop into my mind, filling a space of no distractions. The trill of birdsong and plant scents so strong in the open air were things I had not experienced while enclosed in vehicles transporting me to planned destinations.

I was overwhelmed by the beauty of the coastal path. During online research I discovered it was a designated tranquillity area, free of light and sound pollution. This environment gave me a calm state of mind while coping with the unsettled feelings from lockdown.

The new experience of early morning walks in low light or mist highlighted the transitory beauty of the dew or frost. This provided an opportunity to discover the details of nature, where the unexpected became big moments of the day and created a unique way of looking. As Irish poet and novelist Patrick Kavanagh states:

> 'To know fully even one field or one land is a lifetime's experience.
> In the world of poetic experience it is depth that counts, not width.
> A gap in a hedge, a smooth rock surfacing a narrow lane, a view of
> a woody meadow, the stream at the junction of four small fields –
> these are as much as a man can fully experience.'

Above left: Pay attention.
Be astonished.

Above right: Capturing the
moments of nature: evanescent
dew on grass.

Opposite: Stems stitched to cloth
by tide (see also page 102).

11

A diary line of moments emerged, collected at random, one thought and image leading to another, clumsily flitting between various ideas and working methods to engage again. This resulted in a muddled collection of parts: manipulated old work, new textile samples, sketches, hundreds of photographs, lists of words and phrases, a diary and a step count, newspaper articles and quotes from books. I began to sort them, and my mind, into groups and headings; gradually, a specific context emerged.

I had become immersed in nature, and it was fascinating how it directed me through the development and structure of my work. Compiling and selecting words and images, and discovering their surprising links and associations, can reflect one's unique creative self for hope in an uncertain world.

Below: Capturing moments of nature: tranquillity, a quiet expanse of dandelions.

Opposite: Capturing moments of nature: the fragility of dandelion heads.

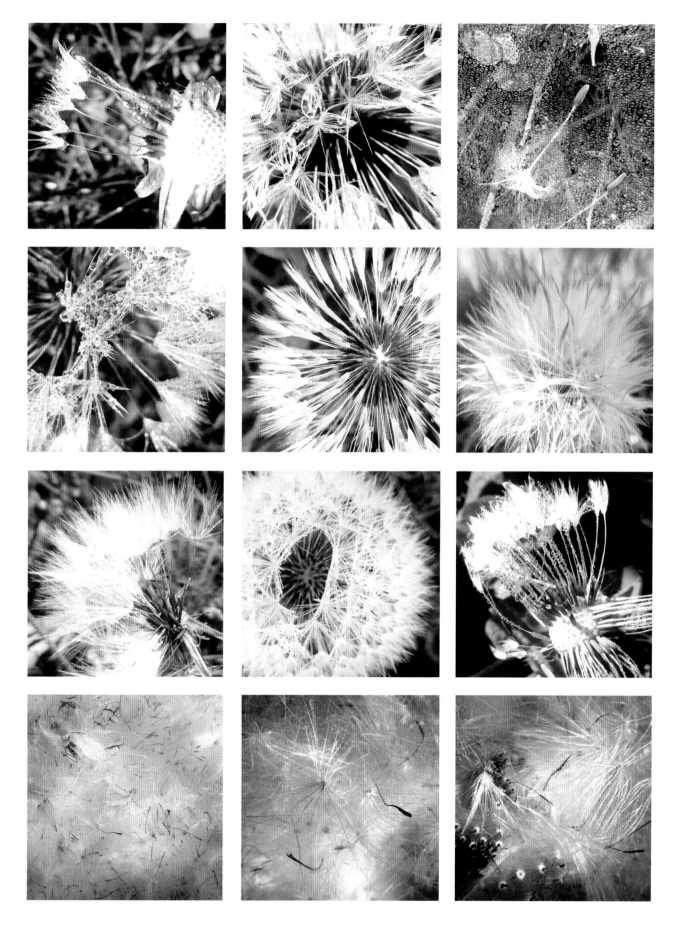

13

Which Way?
Maps and Sketchbooks

*'Each of us, then, should speak of his roads,
his cross roads, his roadside benches;
each one of us should make a surveyor's
map of his lost fields and meadows.
Thoreau said that he had the map of
his fields engraved in his soul ...'*

From 'The Poetics of Space',
Garston Bachelard,
French philosopher

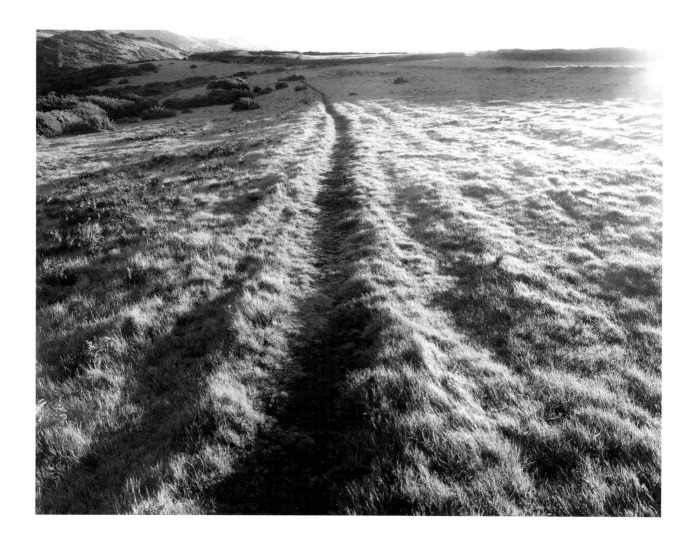

Using sketchbooks

When I wrote 'Which way' in the sketchbook of my first residency, it referred to travelling there, discovering the surrounding environment, and what inspired me on the way. My intention was to develop a design for a textile wall hanging at Nant Mill Visitor Centre, once a fulling mill near Wrexham, Wales. But finding a direction during the pandemic was not easy; with the world in lockdown, my mind seemed to do the same.

 I had never been short of energy and motivation, but the inability to fill a forward planner with exciting projects and travel plans disturbed me. I knew I needed a plan, a manageable project to document my changed circumstances both spatially and emotionally, and do something familiar and comfortable. A sketchbook seemed to be the answer.

Above: Discovering new paths.

Opposite: Collection of sketchbooks. Maps and sketchbooks helped me to find a direction in the changing routes of personal and creative space.

The sketchbook became a map line for both a mental distraction and a focus, to find a route to reveal the root of an idea, as the Scottish painter Victoria Crowe suggests:

> 'A personal symbolic language; a place to play; a place to question; an interpretation of the world; a book of meanings; a memory of trace; a gathering of information; an aid of understanding; a source of laughter and experimentation; a place of poetry and association; a creative journey. Dictionary definitions seem bizarrely inadequate!'

The type of sketchbook I use is influenced by the circumstances; I receive them as gifts and enjoy purchasing them in different locations. Exhibiting with designer bookbinders near Cambridge in 1990 provided me with a beautiful range of shapes and construction. I love the element of surprise while exploring diverse places such as a Japanese temple tourist shop or a village store in a remote part of Australia. I enjoy finding books with a sense of place and purpose, such as my child's writing exercise book from Tbilisi, Georgia.

Collection of sketchbooks.

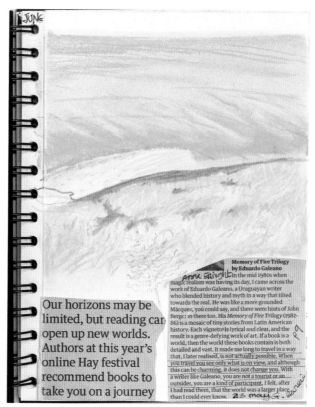
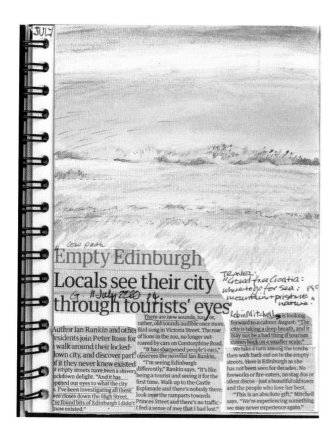

Sketchbook details.

The shape and style of a sketchbook can affect how you make the marks within its form. I had found a beautiful folding book in Japan just before arriving in Alice Springs for a backpacker's journey down to Adelaide in Australia. The concertina shape revealed one folded page at a time, which was ideal when I was squashed on a bus full of young travellers. Keeping the same horizon line throughout the folded pages enabled the whole journey to be seen when the book was pulled open. The continuous line held a week's journey where I worked along the page without thought of time or restrictions. Sadly, the sketchbook went missing during an exhibition, leaving me with an internal story rather than holding the reality in my hand.

Now a different effect of time and constraint had to be drawn, a repeated daily walking route as far as my body was able. A Christmas gift from my daughter was a Seawhite Octopus Concertina Sketchbook with eight folding pages extending from a spiral-bound spine. Immediately I saw the potential of each folded paper length representing eight months, with the four pages either side providing space for two pages per week. Knowing when this project would end gave me a feeling of hope, a small certainty for my unsettled mind. Although I had a structure for completing two pages per week, I struggled, as my enthusiasm lessened with the unfolding news of the National Health Service being placed under great strain and a rising death toll. Another distraction was needed, so I looked for a context around the pandemic that linked with the issues of my work.

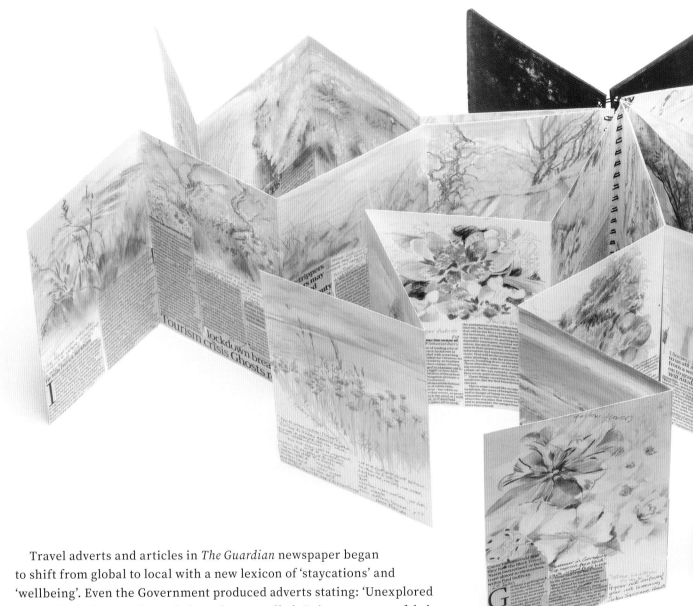

Travel adverts and articles in *The Guardian* newspaper began
to shift from global to local with a new lexicon of 'staycations' and
'wellbeing'. Even the Government produced adverts stating: 'Unexplored
England: Find the paths and places less travelled. Enjoy summer safely.'

I pasted this new journalism of travel and the environment below drawings
of seasonal changes on the coastal paths. The sense of a journey was now split
into months, a designated space for blocks of time rather than a continual line.

The shape and marks within the book can trigger visual recognition of other forms
or actions. The folding book I created during my Australian backpacking trip gave me an
immediate reference to the folding cloth emerging from the needlefelt machine during
my residency at the University of Huddersfield in 2003. The continual line of merging
colour was like watching a moving landscape from a train or car window.

This evolved into my largest installation, featured in the 'Through the Surface' touring
exhibition during 2004, curated by Professor Lesley Millar. The suspended folding form
was extended to fit the space it occupied, whether at the Sainsbury Centre in Norfolk
or the Museum of Modern Art in Kyoto. The double-sided continual length of cloth
suggested the shifting moods within a journey and was titled *Land Line: Double Edged
Encounters*. The lost sketchbook had inspired a monumental form, a space filled with a
line of journeys, and is now part of the permanent textile collection at Nottingham Castle
Museum and Art Gallery.

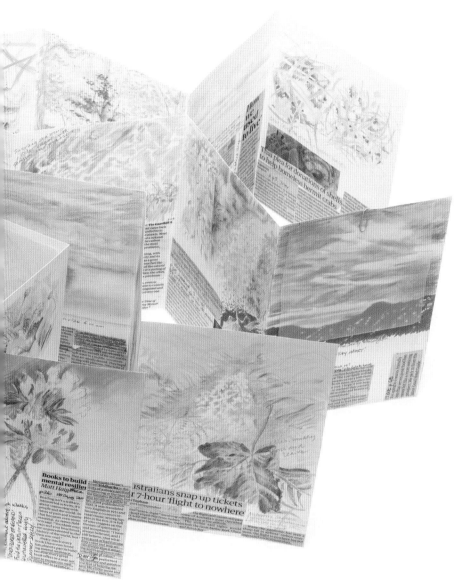

Left: Lockdown sketchbook.

Below: Land x Line: Double-Edged Encounters (2003), 28.4 x 0.6 x 3m (93 x 2 x 10ft), Sainsbury Centre, Norwich. Artist-produced needlefelt, machine-embroidered labels, heat-transfer images. Produced for 'Through the Surface', featuring collaborating textile artists from the UK and Japan. Photographed by Pete Huggins.

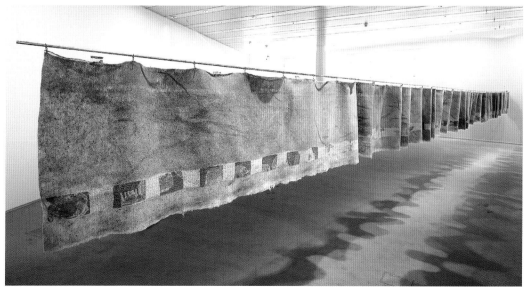

My first experience of a sketchbook came when I was ten years old on a beach in Devon, watching an artist draw the rugged cliffs. I was mesmerized as the rocky forms gradually appeared on the blank page, and my feeling of wonder enticed me to also produce this magic. My childhood was quiet and calm with no distractions from social media or computer games, and I had uninterrupted time to develop making and drawing skills. These also became survival skills as I failed academically partially due to dyslexia, and drawing became the one element in my life that gave me success and self-esteem. I despair at the lack of opportunities the government provide for children who cannot answer exams by rote and need to have creative avenues open to them. The reduction of funding for art education and creative opportunities will cause a sense of failure for many young people. Everyone has a success story, but they need a structure to experiment and discover what this might be.

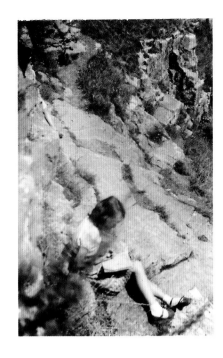

Left: Detail from a sketchbook used during lockdown.

Above: Jeanette Appleton sketching as a child, photographed by Ronald Campbell.

Opposite: Various steps.

it's raining, it's pouring

Melissa Harrison

In 2016 I published a book called Rain: Four Walks in English Weather. The idea for it came to me in Cumbria, on a walking holiday during which the lakes that give the district its name were generously, and daily, refilled.

To write the book, I visited four very different landscapes to see how rain changed the ways they looked and sounded and smelled, and what effect it had on living things. I walked in winter rain in the marshy East Anglian fens, explored Shropshire's rich farmlands in showery spring weather, followed a Kent chalk stream during a thundery summer cloudburst, and scaled Devon's granite uplands in autumn drizzle to watch how it ran off the high ground in "flashy" rivers such as the Dart. Each time, I went out in what we lazily characterise as "bad" Going out when other people went in usually meant I had the place to myself, and I often saw more wildlife than I would have otherwise: swallows flying low before an incoming weather front; rain flies congregating on Queen Anne's lace; and scarlet pimpernel closing its petals at the approach of a storm. I got to experience a whole suite of sounds and smells and views that had been denied to me when I'd been afraid of a little rain.

There's so much to enjoy on a wet walk, whether you live in the countryside or a city centre: the rainbow sheen on puddles created as decaying leaves release their plant oils; the prints of birds and animals in mud giving clues to the secret lives of our non-human neighbours; the differently coloured deposits of sand, sorted by weight and left there by water along a footpath that has overnight become a stream. The air is washed clean, birds in the hedges are fat balls of feathers, and the pavements shine; and as you walk, you can listen to the rain pattering on your clothing, which is like being safe and dry inside a tent.

There's no need to let a bit of precipitation stop you enjoying the outdoors this winter. We all need to be connected to nature, whatever the weather - now more than ever, in fact.

Using maps and mapping

Mapping your experience in different ways can help you visually position yourself in a portion of time and place. A discussion about preventative measures against Covid-19 on *Woman's Hour* (BBC Radio 4) suggested that walking 10,000 steps a day was good for the immune system. This triggered an obsession with monitoring my step count every day; as they accumulated I realized that after a year I had walked to my studio in Spain! The counted steps had created a direction of distance and an aerial measurement other than the actual experience.

Fascinating images of steps were everywhere during this time of social distancing. Signs depicting the position of feet, space between people and walking directions created a spatial awareness not considered before. There were even steps embedded into concrete, mapping the coastal path through the town with the words 'Ilfracombe – curious coastal charm', which I was certainly experiencing. The contrasts between personal and ordered directions, aerial measurement and mapped experience expanded my notion of virtual travel and spatial experiences.

Books on mapping have always fascinated me and helped me to understand the spatial element of travel and offered me a language that often helps to resolve work in progress. I was reading one after finishing an Artist in Art School residency at the University of Hertfordshire in 2000, where I had experimented with printing on felt using the university's large heat transfer printing press, and I still had an example on my studio wall. The printed images had been selected from events filmed within a grounded helicopter during an ethnographic research trip to the Republic of Georgia.

I was also trying to find associations with 'Red', a title for the 62 Group of Textile Artists exhibition for their 40th anniversary. The link to pull these diverse ideas together came from reading the mapping term 'the red line of danger'. I laid a length of red thread over the printed images; immediately, to my surprise, the line crossed out the events at the time, creating a reflection of current issues of refugees and land.

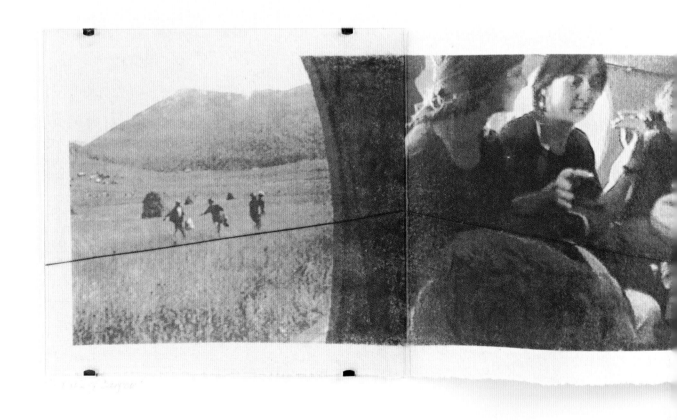

The emphasis changed to creating a restrictive line to drawing the intentions of the people in and out of the helicopter and the surrounding space. The soldiers guiding us to the military helicopter now seemed to be guarding us. The figures carrying bundles of belongings to move to the warmer valley for the winter conveyed a sense of urgency of fleeing the land, cut off behind the line. Not only was it a new experience travelling by helicopter but also using the video camera as a sketchbook. Because I had little knowledge of the video's functions, I just pointed it towards the action and let it capture and document the process of experience. Unlike a camera where the view is selected for a single image, these are found between the video stills, revealing atmosphere and action not always realized at the time. The words 'a red line of danger' changed my act of seeing the different interactions of people with place because the narrative had been triggered by a creative action with a line of thread.

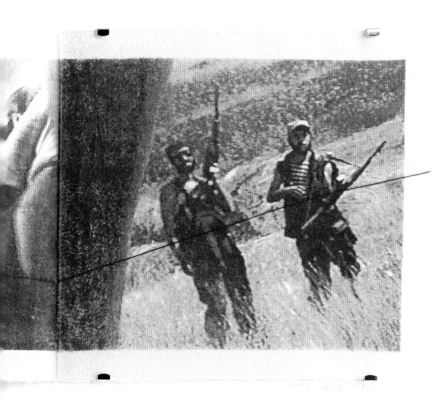

Nomad: The Red Line of Danger *(2000), 50 x 103 x 4cm (20 x 40½ x 1½in). Transfer printing, glass and metal. Photographed by howaboutdave.*

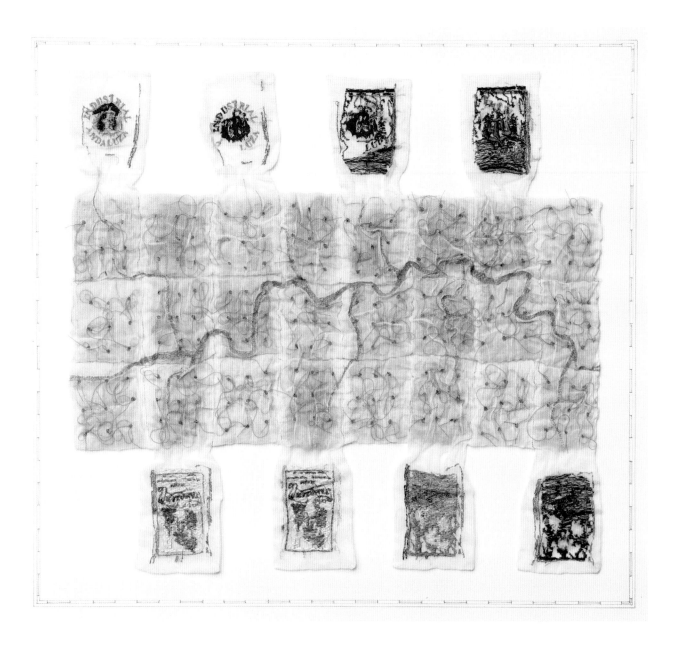

The use of colour and symbols on maps identifies categories of value and meaning to the space you occupy. A blue line or shape represents a river or a body of water, showing the entire perspective, which is not possible by direct experience. I explored these lines of perception by using the shape of the river running through the valley of the Alpujarras in southern Spain with the roots of seedlings seen during research at the John Innes Institute in Norwich for *On Route: In Root*. This was developed during my residency in 2006 at Huddersfield University, when I was able to experiment with the Amaya multi-head sewing machine. The machine stitched the scanned tourist images from sugar packets, which I had collected while travelling through Spain, onto silk organza. These were similar to the cellophane bags placed over plants to stop cross-pollination at the John Innes Institute (see opposite). Creating a collage of various mapping experiences and images added another layer of relevance to mundane objects that identify place and time.

Opposite: On Route: In Root (2007), 41 x 37cm (16 x 14½in). Machine stitched and quilted.

Below and bottom right: On Route: In Root (details).

Bottom left: Cellophane bags placed over plants.

I felt the depth of time walking ancient routes on the undisturbed headland, sensing that the space held a special aura. I checked the local council website, which had a map of the heritage coastal area of my walks, and I was not surprised to find that it was an officially recognized area of natural beauty. The Biosphere Reserve and management plan now considers 'a new breed of Landscape Character Assessment (seeming more personal and human)'. The land areas were colour-coded to represent National Character Areas or Landscape Character Types, emphasizing the mapping narrative to reference humanizing the land. The position of the human with the land was accentuated in the pandemic, including the need for open spaces to recover from trauma for one's wellbeing and in turn to treat the land with care.

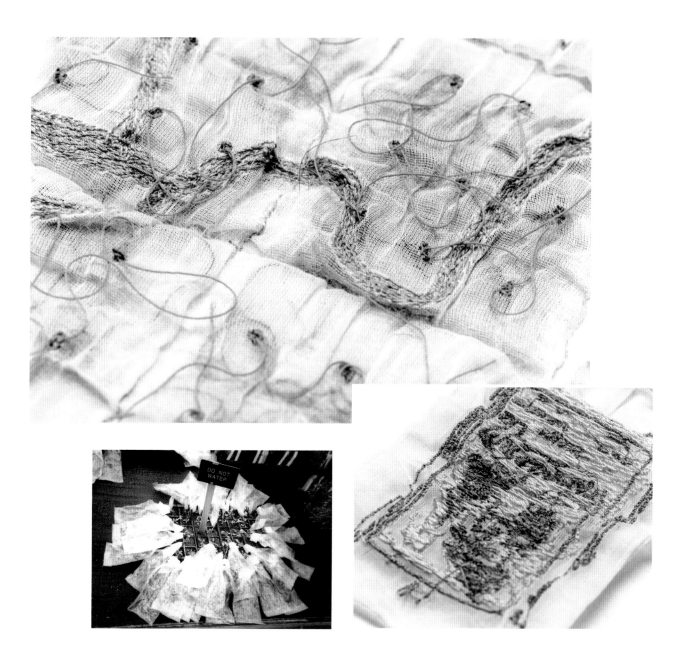

It was interesting to read under the Historic Environment and Culture section that the area has a long history of human habitation that is 'woven into the landscape, with some threads tracing back to pre-historic times'.

Using these textile references to describe a historical place resonated with me, as I had just researched the weaving of Ethel Mairet (1872–1952), who had collected fossils in these areas with her first husband, the geologist Ananda Coomaraswamy (1877–1947). Mairet had been born and educated locally in Barnstaple, Devon, and although the museum has no textiles it does hold a large collection of these fossils. Later, after lockdown, I was able to research the collection and felt her presence as I handled and drew the fossils. I gently turned them in my hands to peer at the tiny writing on the tenuously attached labels stating the place and date where they were found. I was drawing and handling a line of thought and enquiry, mapping her intentions then and mine now. We were both textile artists exploring and inspired by the same sites of nature in different times and from different life perspectives.

Samples were produced to explore the trapped line within a form throughout the different stages of the felting process. Twisted threads of wool and silk paper yarn were added under a thin layer of wool before felting, placed into pre-felts or stitched into cut lines of firm felt. Lines of thread were also slipped under the surface of finished felt for a mark not affected by the shrinking process. The qualities of mark expressed the gradual revealing through time and the tenuous preserved lines of nature.

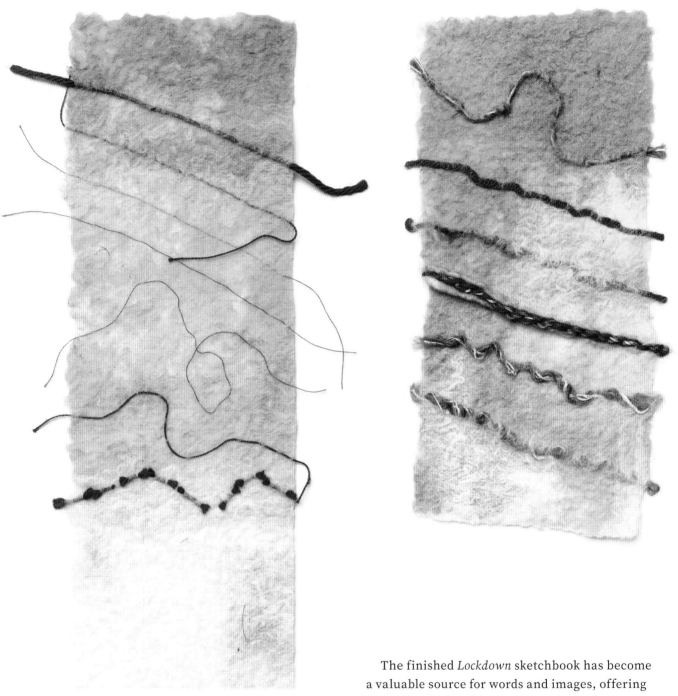

Above and above right: Embedded and surface lines with different threads.

The finished *Lockdown* sketchbook has become a valuable source for words and images, offering a social and historical document for the next generation. There is something poignant about reading about a family member's life during a specific time. The two diaries I have of my mother's portray this: I have one from when she first met my father, before they were married; and another from after they separated, when she created a space of her own. Extreme emotional moments trigger the need to document heightened feelings of change and capture the journey of finding a way forward.

Stitching Over the Past

'Beauty illustrates happiness: the wind in the
grass, the glistening waves following each other,
the flight of birds – all speak of happiness.'

Agnes Martin, American painter

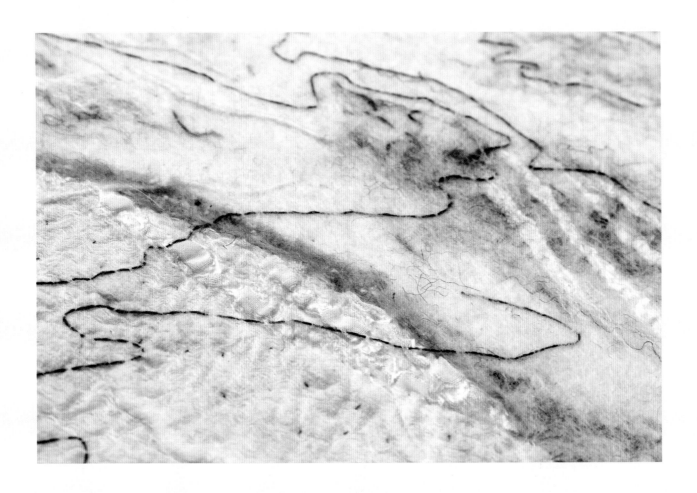

A thread and a stitch can illustrate and express many thoughts and meanings. Besides the action of making and mending, they can hold historical references and ancient myths. The first needle and thread evolved from nature, a nettle yarn used for a human's need for practical construction. Writers often refer to thread and stitch to deepen the expression and emotion of body and place, for a significant time of nature, humanity and hope.

Thread steeped with memories was cherished by a character in a novel by the Australian writer David Malouf. As a prisoner of war, he held on to hope to survive the camp by a piece of thread hidden in his pocket. 'Finally he hung onto it just for itself, whether it was useful or not ... If he lost it he would be done for.'

I reached for lines of thread to unravel the uncertainty and find an understanding of what I was seeing and feeling on my daily walk. Artist Paul Klee suggested that a line can express the essence of nature, and I was certainly seeing many lines in various forms.

I sought solace in the paintings of Agnes Martin (1912–2004), which seem to hold lines of emotions that echo the subtle moods and contrasts of the new landscape I was immersed in. They emphasize the huge difference in one format, highlighting the essence of linear spaces as 'silent paintings' of 'floating abstractions'. Martin realized the importance of seeing and feeling simultaneously, explaining: 'Beauty is the mystery of life. It is not just in the eye. It is in the mind ... It is a mental and emotional response that we make.'

My response was influenced by a mental space that I was eager to fill with positive thoughts, how and what caught my eye reflected in the moment. Martin's texture of paint using subtle colour and tones were what I saw in the slight changes of light reflected on grass and sea.

Above left: Waves of lines.

Above right: Transitory lines reflected in the moment.

Opposite: Detail from Changing Currents: Challenging Changes *(see pages 40–43).*

I realized the bombardment of constant cultural changes that I had travelled through had not allowed for this meditative contemplation. I was used to collecting strong contrasts, but now I had to become more perceptive to subtleties. I was no longer getting rushed glimpses but slower, thorough looking, repetitive acts of listening and being still. Previously I had been influenced by travel adverts, creating expectations that influenced my response to a historical site or a beautiful view. Now I had no idea of what to expect, relying on my intuition, emotions and art-trained eye to select and collect an experience to translate through a creative process. I was able to watch hidden fungi gradually peeping through the grass, grow whole and colourful, and become lacy by the action of slugs. The most amazing moment was the effect of frost, the transitory time of nature caught in exquisite sculptures, demonstrating qualities to inspire textiles. My pace and attitude totally changed, as Ralph Waldo Emerson states: 'Adopt the pace of nature: her secret is patience.'

Subtle contrasts.

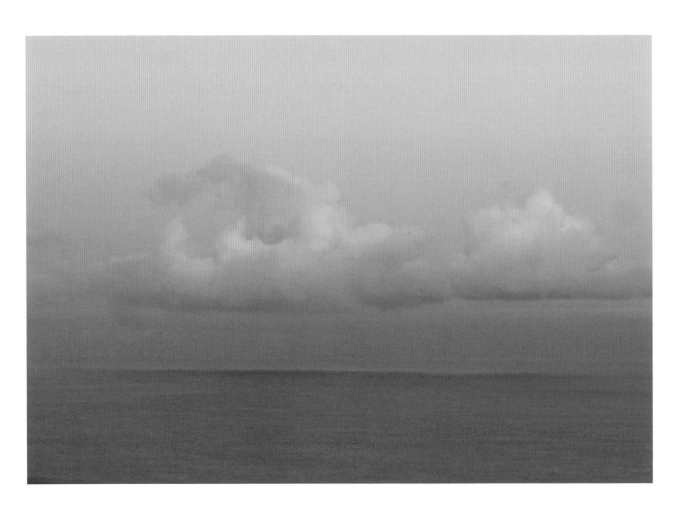

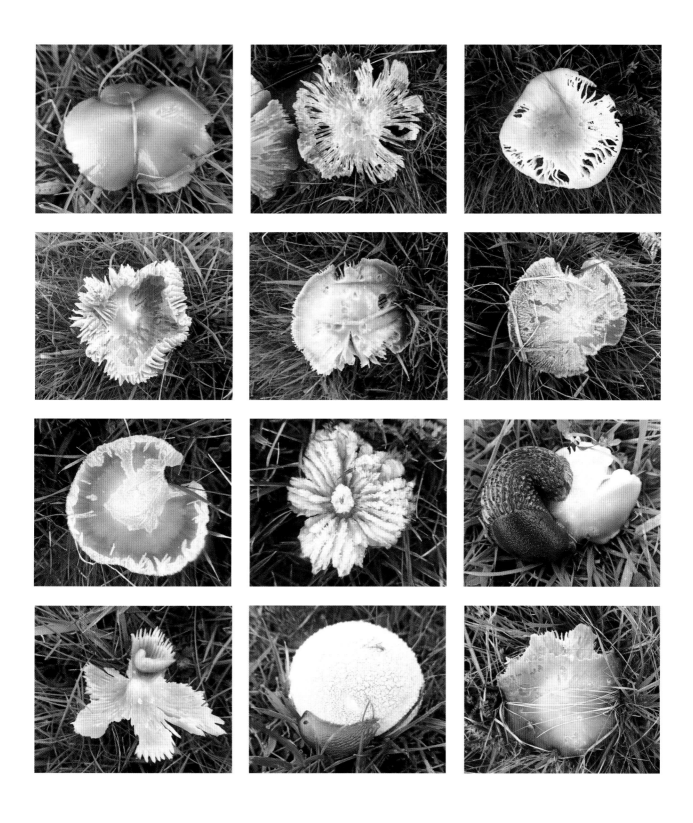

Repetitive acts of seeking nature's detail.

Floating lines

Visiting the 'Loose Threads' exhibition at the Serpentine Gallery in 1998 was the first time I had seen artists using thread directly in the space of a major fine art gallery. It was intriguing to see the paintings of Dutch artist Michael Raedecker in which lines of thread on the canvas were secured when paint filled the spaces. These unattached threads not employed in a tradition of attaching portray ethereal and intangible qualities that nature also creates.

I witnessed the memorable sight of long lines of filaments floating in the air as I sat on the terrace adjoining my studio in Spain. At first I enjoyed the mystery, but gradually I saw the reality of cobwebs suspended above the valley of warm air, caught by rays of light. Letting threads fall on a base and attached to the given shape seemed to capture an energy and essence of form.

Above: Dry Drifting Shadows: Alpujarras *(2010), 91 x 56 x 2cm (36½ x 22 x ¾in). Needlefelt, silk fabric and hemp string. Photographed by Peter Stockdale.*

Below: Iced puddles.

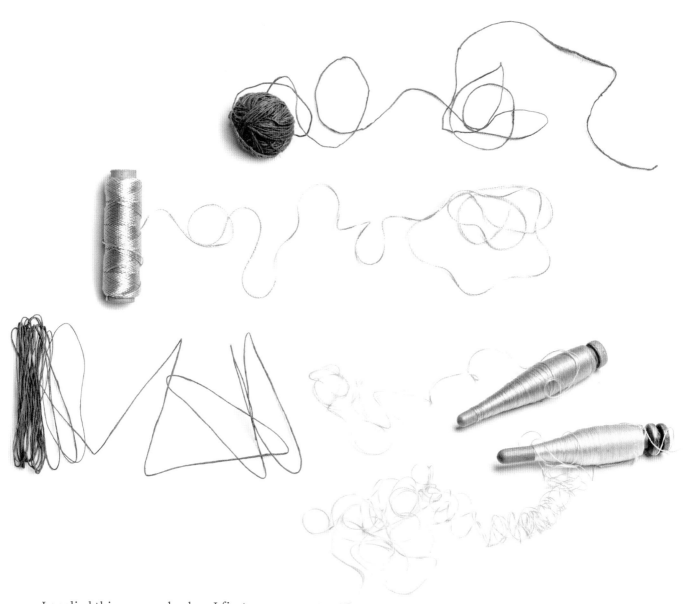

I applied this approach when I first
used hemp string on *Dry Drifting Shadows:
Alpujarras*, reflecting the views surrounding
my studio. Another type of floating lines was later
seen in the iced puddles on the headland, with
stunning linear forms cracking over muddy sediment.

There is a purity and personality to the thread
before it is threaded into the needle and submerged
into a stitch. The thread has a subtle form when
unwound or unfolded, whether natural or synthetic,
as the material affects the structure and quality of
the line. It is interesting to see how the shape changes
depending on how the thread is stored, whether
wrapped or skeined, creating folds or loops. They
resemble patterns of vines and stalks growing in
nature, twisting or bending as they reach for support,
as with thread reaching for a cloth to attach to.

Above: Thread Forms

Below: Twisting stems.

I had explored this quality of mark when representing the linear patterns of light and shadow of the ploughed furrows around olive and almond trees. They were part of the work produced for a solo show, 'Sew:Sow', when I had funded research at Huddersfield University with access to the industrial needlefelt machine, where the wool is carded, layered and bonded by barbed needles pulling up the fibre into a continual length of cloth. While using the machine, there had been a moment when a disruption in the process made some of the peaks from the barbed needles more pronounced. I thought of this unique structure as a mutant, which a plant scientist had explained was what they looked for in nature (analyzing a mutant plant structure gave a better understanding of the normal plant). A stiff cotton thread was slipped through the very tips of the peaks to suggest the floating ploughed lines, while the repeated regular points were like the dots of mass-planted trees seen from above.

Above: Nomad: The Red Line of Danger *(see pages 22–23); detail of thread secured by the glass. Photographed by howaboutdave.*

Opposite: Stitched needlefelt.

In the previous chapter, I described how the work *Nomad: The Red Line of Danger* was resolved by placing a red thread over the printed images on felt. It was important for the thread to float as a line, because securing it by stitch would destroy the power of the tenuous moment the red line represented. It would 'disappear into pure experience', as the painter Michael Raedecker's use of thread has been described. But how could I secure the thread and keep the fragile inside/outside quality in its presentation and framing? I experimented by using mirror clips to hold two pieces of glass onto a backing board, leaving a space between. This enabled the middle section of the felt to remain free, curving slightly forward with the loose thread as it was trapped either side under the glass. Considering the space and display of the textile can become an important component of the work.

Nature and thread lines

Stitching is a trait inherited from my tailor mother and, as it requires little thought, it was the first action to consider out of creative lockdown. In desperation, old pre-felts, partly felted and dried, were cut into squares and chosen at random to stitch into after my morning walk. They were pinned daily on a large sheet of card for a possible composition, but after a week I found myself re-thinking and making choices again. Squares were selected in response to my mood and what I had seen on my walk, represented by a thread type, colour and stitch shape. This was an extraordinarily simple but effective way to kickstart a creative path, as I began responding to the idea of 'uncertainty' as an action and structure in the making process.

The stitched squares still remain as sketches and are often moved around to activate the creative thinking that I should be engaged with. Some evoked a theme and were added to an arrangement of images and cloth for a future project.

Random sketches – stitched pre-felt squares.

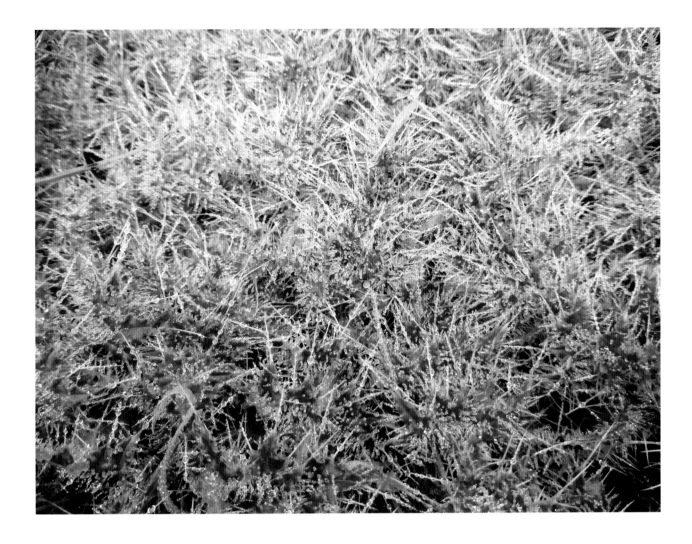

The movement of the needle and thread between eye, hand and cloth mesmerized me and distracted me from negative thoughts. The exercise had activated my imagination to observe and transform lines in nature as thread and stitch. It was interesting to discover these qualities explored by writers and artists, as I read many books through the pandemic. The main character in John Berger's novel *G.* walks in the forest and notices a single twig of a larch and considers:

> *'when the twig was smaller, each of these was a needle ... The forest is the result of the same stitch being endlessly repeated.'*

The Russian painter Wassily Kandinsky saw that

> *'the leaf of every deciduous tree has its linear network of veins, every needle of the conifer is a thread-line in itself.'*

These phrases and descriptions echoed my own thoughts, expanding a new perspective to identify shapes and meaning in nature.

Dew-covered gorse.

I was now travelling in my imagination via thread and stitch, but I was still not able to engage with actually making the felt cloth. It had always provided a direct connection to land and travel, but now I was no longer nomadic, was it still relevant?

As I was not able to move on, I looked back, finding old felt that I could work into directly. Laying threads on a finished cloth was an exercise I used to generate motivation, starting at the end of the felt process rather than at the beginning.

I was surprised that the marks and shapes of previously made felt began to materialize into what I was seeing now on the coastal path and meadows. This cloth connected me to my walking route rather than, as in the past, a site would direct the making of the cloth. Gradually, the process brought me closer to nature, appreciating the subtle variation of thread and stitch with the nuances of nature and seasonal changes. This displacement activity had the positive result of releasing my inner conflicts into tangible marks on cloth and the beginning of a new direction.

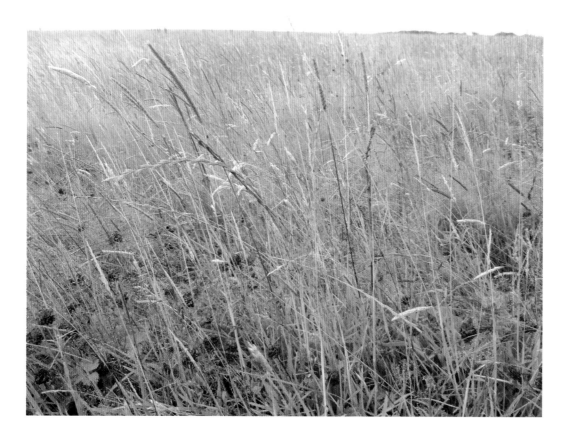

Above: Coloured lines, vulnerable threads.

Opposite: Coloured grass.

Removing the usual starting point of my textile practice (to manipulate and bond fibre) was like the result of how the pandemic provided an opportunity to expand limited experience in more depth. I soon noticed I was focusing on the basic shape of line and selecting threads with care to capture the contrasts between sea, grass and hedge. Stitch was purposely made unstable by threading the yarn under minute filaments of fibre on the felted surface. Cutting and leaving the thread ends loose created an edgy feeling, as they could easily be pulled or slip out, echoing the tenuous state of nature.

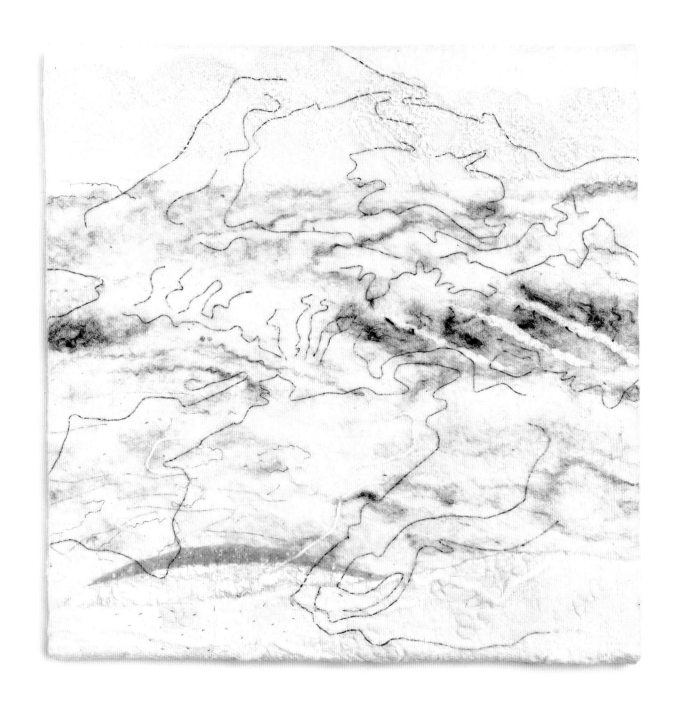

*'The heart of man is very much like the sea,
it has its storms, it has its tides
and in its depths it has its pearls too.'*

Vincent van Gogh, Dutch painter

Above and opposite: Changing
Currents: Challenging Changes
*(2021), 144 x 36 x 2cm
(56¾ x 14¼ x ¾in) group,
35.5 x 35.5cm (14 x 14in)
each. Reconfigured work with
surface stitch.*

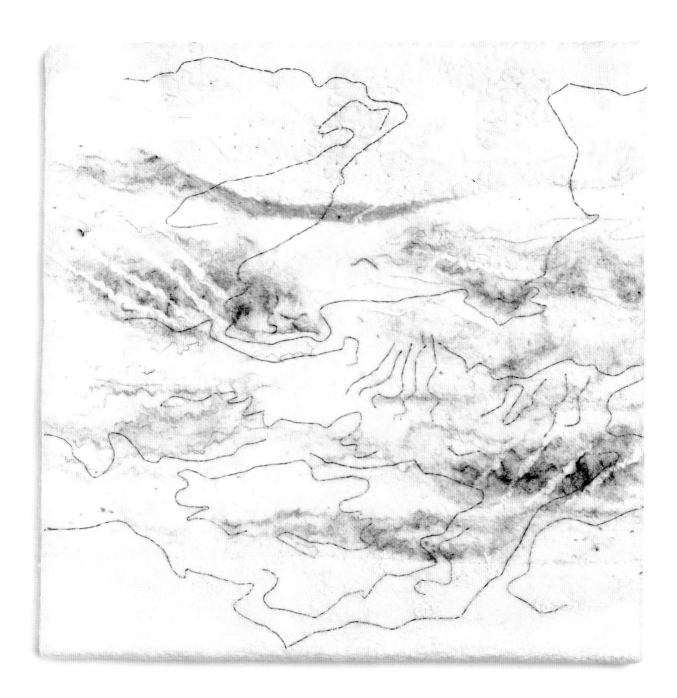

Sea lines

Sea lines come and go, reflecting the uncertain undercurrents of lockdown.

Frequently looking down on the same cove, I witnessed the shape of surf lines folding in or out between the rocks. Every day, the tide line would shift up and down the beach, mysteriously governed by the moon. For the first time I was aware of the topography within the undercurrents and sound waves unseen below. This seemed to mirror my challenging emotions, the churning inner uncertainties, while I was trying to remain outwardly calm and positive. Sorting through old work, I realized this feeling was reflected in a couple of small pieces, especially that morning's bleached turbulent scene of churning surf flinging foam across the beach.

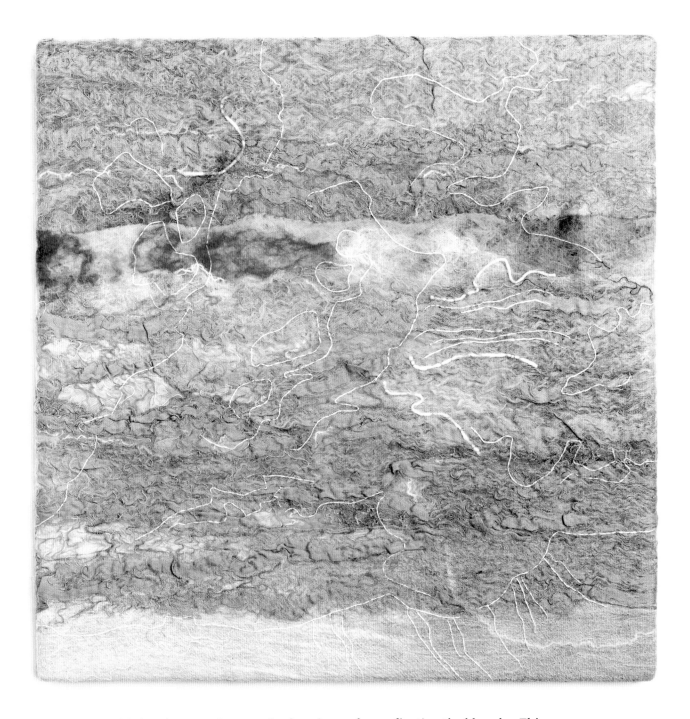

The sea could also show another mood; of a calm surface reflecting the blue sky. This image was found in a larger blue textile that I reshaped to the same size as the other two, creating a set of adjoining opposites. The different shapes of line were stitched with white wool thread to convey clean, fine tide lines. This provided the first hands-on work again. Although this began as an exercise, the four pieces seemed to form a finished work when hung side by side on the wall. This arrangement triggered a series of words and the title *Changing Currents: Challenging Changes*.

sound waves of future
topography self and sea
under currents bond

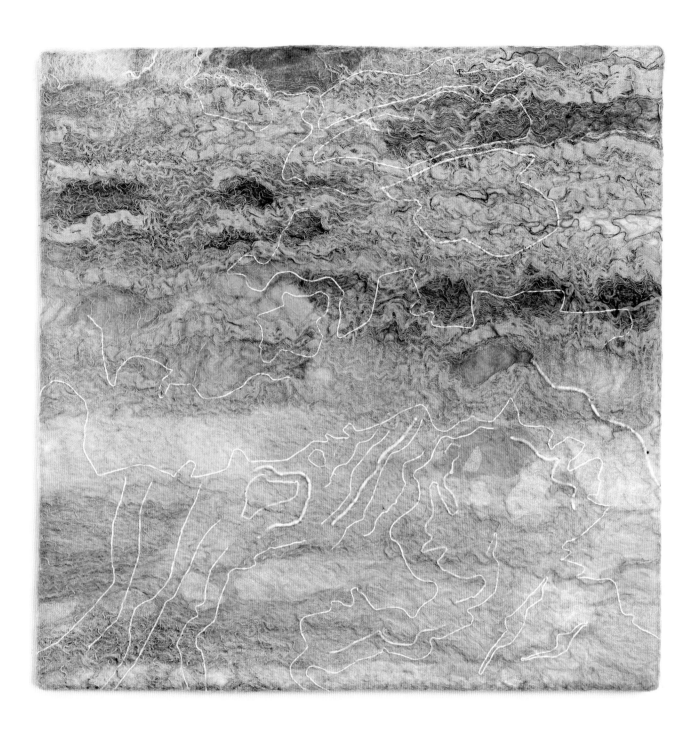

Opposite and above: Changing Currents: Challenging Changes *(2021),*
144 x 36 x 2cm (56¾ x 14¼ x ¾in) group, 35.5 x 35.5cm (14 x 14in) each.
Reconfigured work with surface stitch.

Hedge lines

'The frothing of the hedges I keep deep inside me.'

Jean Wahl, French philosopher

Hedges provided a layered depth of line, as if crossing out the past, and was too dense to see through to the future. As I looked into miles of mixed trees and shrubs, childhood memories returned of daily walks scrambling in and out of hedges. But I was now looking into a Devon hedge planted on a turf bank, a specific local symbol and personality of place.

With time to research I found the fascinating Hooper's rule, formulated in 1965 by English naturalist Max Hooper while investigating the disappearance of hedges because of the growth of intensive farming. He surveyed the relationship between the age and the number of plants in a particular length of hedge, describing hawthorn, blackthorn and hazel as a magic three, due to their intensive role in controlling the land as a barrier from animals. This directed my gaze to select these shapes and consider their differences through the seasons. Each plant was chosen for a purpose, which inspired me to select shapes and threads to depict the purpose of my ideas.

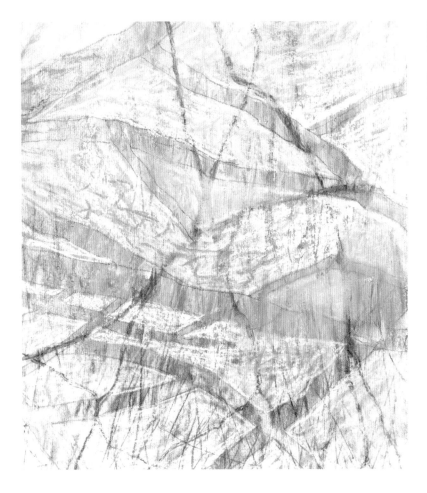
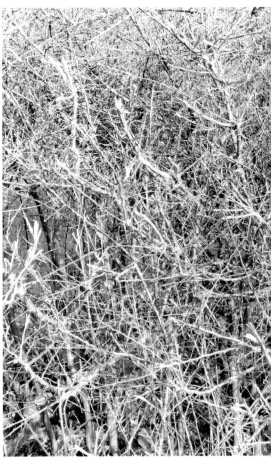

The small samples I called *Hedge Edges Between* were slowly developed as sketches, not as finished work, to allow me to play freely and learn from mistakes. This was also my approach to the drawings, with many layers of lines rubbed out and drawn again. I considered the space between the branches to be like cracking or veiling nature's vulnerability.

I saw so many differences from the constant view of hedges accompanying my walks, such as spindly, criss-cross lines of woven branches or twisted thorn lines of threading brambles. A long hedge line had been severely cut by machine and I felt the pain of the ripped and exposed ragged ends, which seemed to represent the constant destruction of nature. But nature is being valued again, and a deeper understanding of plants and their role in land management has led to the creation of many re-wilding projects encouraging the protection of pollinators and the biosphere.

the hedge edges between
layered lines veiling a
right of way to loss

Below: Machine-trimmed hedge.

Below left: Hedge drawing.

Below right: Hedge Edges Between *(2021), 30.5 x 30.5cm (12 x 12in). Reconfigured work with surface stitch.*

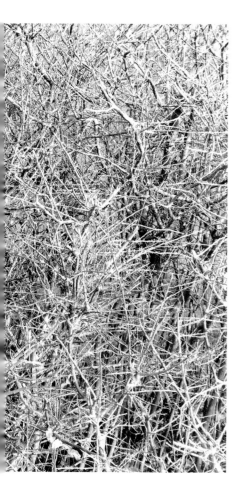

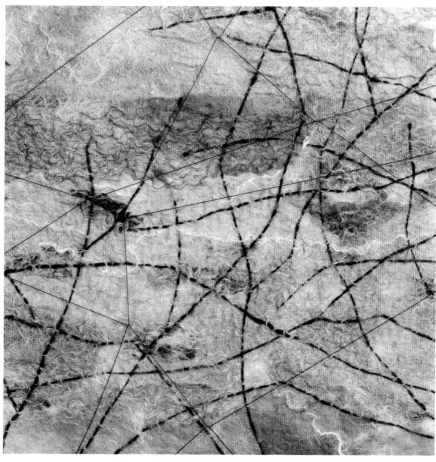

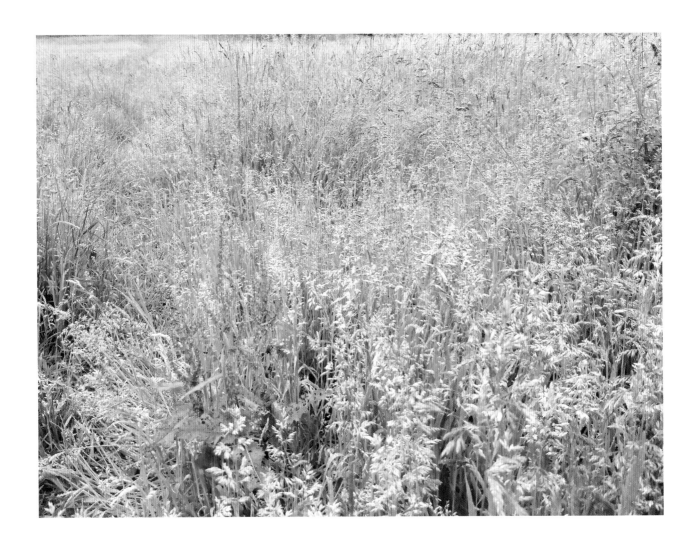

Grass lines

Oh, my dear heart,
my own dear heart,
full of hesitations,
questions, choice of directions,

look at the world.
Behold the morning glory,
the meanest flower, the ragweed,
the thistle.
Look at the grass.

Mary Oliver, American poet

Above: Grass at a distance.

Grass on the headland and farmland displayed lines
that changed with seasonal growth and disintegration.

Opposite: Grass details.

'A Manifesto for Fields' by Common Ground, published in 1997, listed 41 items; the last one stated: 'Fields should feast on imaginations'. As a child I did just that. My first nature collection was of grasses sellotaped into an exercise book and added to the nature table where my mother encouraged my brother and I to display the discoveries from our daily walks. Grass is everywhere, of course, even squeezing through cracks in concrete, but its beauty and character are often taken for granted. Two views always give me joy – detail and distance – stopping and looking down at their individual shape or walking towards an area of subtle coloured tones.

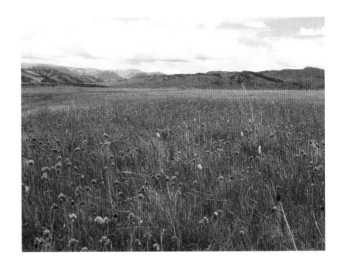

Above: A pristine Mongolian landscape.

Below: Making cloth on land.

One very special view occurred when I was suspended above the grass and my position of looking was dictated by the pace of a horse. My senses were alert to the rhythm of the hooves and scent from the acres of crushed herbs on the Mongolian steppe. An amazing ethnographic research trip organized by my friend and fellow textile artist Lene Nielson in 1997 had brought me to this pristine land, where herbs and alpine plants grew amid the grass because it had not been disturbed by humans.

The nomadic method of felting uses hand-sheared wool, layered in different directions to enable the scales of the fibre to interlock. After throwing cold water over the layers of wool it is rolled and wrapped in leather. Two horses pull the roll back and forth across the land until the fibres are matted together ready to cover the portable shelter. The

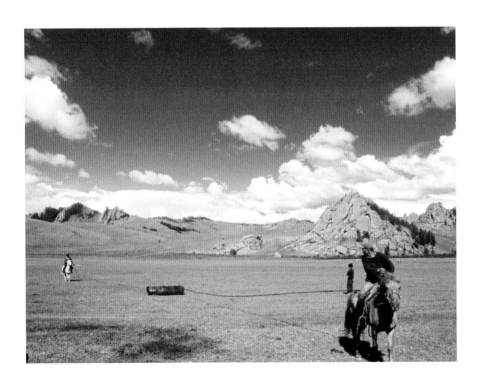

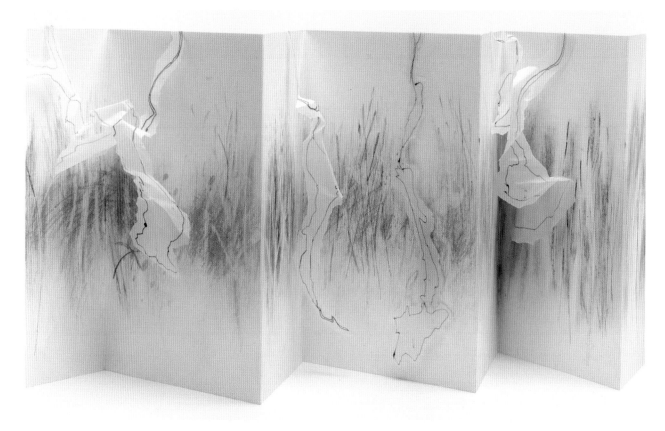

Above: Sketchbook detail.

Right: Frosted line.

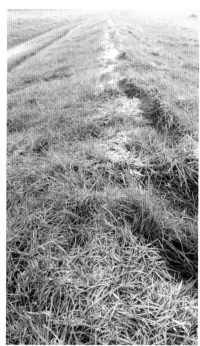

sounds of the riders urging the horses on was music to my ears as I watched the source of my textile practice.

The pandemic caused a hesitancy of choice and direction for a safe isolated path, and I began to consider the position of my body and how and where I moved on different types of ground and in different weather conditions. Moving along verges or across meadows, around trees or through gaps in hedges, up and down steep hills and along the sea edge shifted the ideas and attitudes of my position in nature.

By coincidence, the first exhibition I visited after lockdown was a photographic display of Richard Long's installations and documented walks at Thelma Hulbert Gallery in Honiton, Devon. His unique map structures showed the different routes on and off the path or with measured walking within a shape on the map, creating a different spatial understanding. I was fortunate to visit with a friend, the painter Frances Hatch, who also works with the land. We both slowly savoured viewing art first-hand and the release of isolation heightened our attention. Valuable time was spent looking and discussing in more detail than before, exchanging and extending one's perspective.

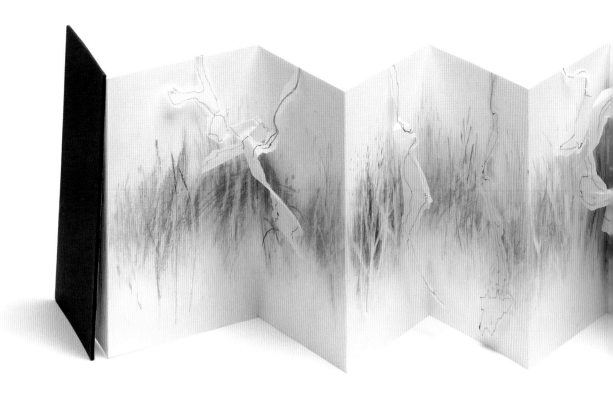

Influenced by Long's maps, I began to record a spatial line, an interval of time and distance between two points. The daily circular walks had been traced from a local map onto crisp transparent paper. When pinned on the studio wall, the shapes resembled dried, twisted leaves. I began a new sketchbook to draw a line of marks using local soil to explore the constant changing grasses on my walks. The structure of the book created a gap in the top of each folded page and I wondered how to use this space. First

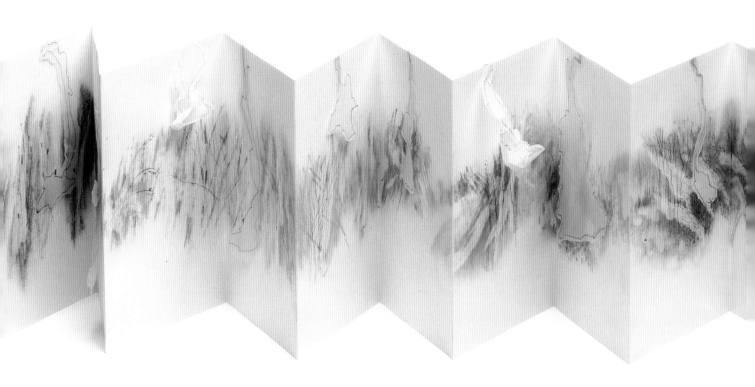

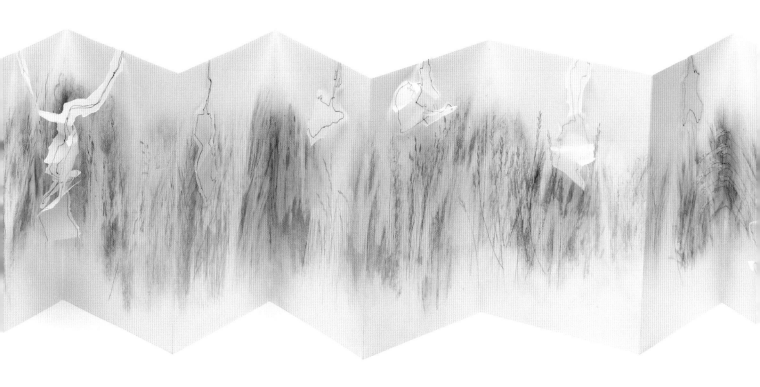

I slipped dried grasses in between the folds, but then my eye was caught by the neglected, traced walked shapes on the wall. For no reason other than the love of shifting things to discover their effect in different places, the ends of the traced shapes were folded and slipped into the edge. They had found a home, giving the impression of nature's fragility as they hung above the drawn line of marks. The contrasts between an aerial and a land view of my walks was conveyed with a continual or an enclosed line.

Sketchbook.
15 x 21 x 2.5cm
(6 x 8 x 1in),
closed.

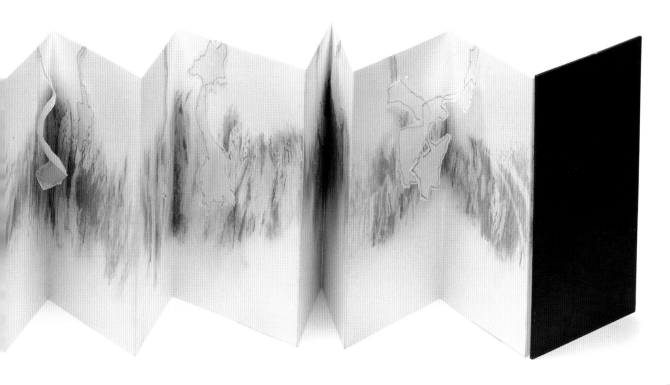

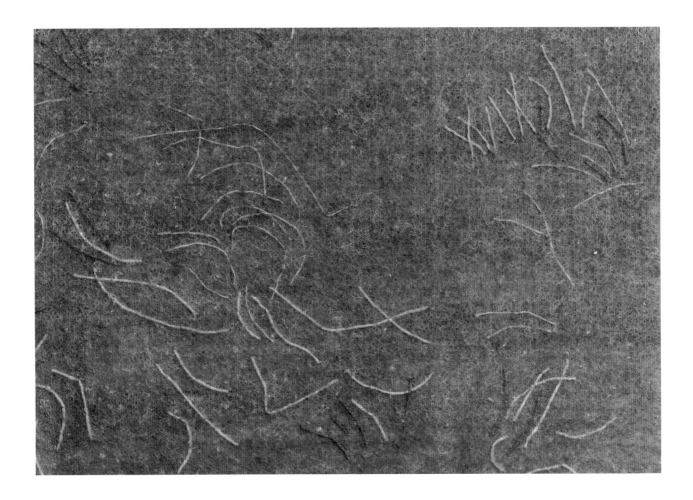

The exhibition had focused my walks more spatially, as the direction and position on the paths would give me a different view of the same grassy area through the seasons, whether I stayed steadfastly on the designated footpath or on a random route that often followed the animal tracks. The grass lines would be affected by seasonal growth and disintegration, the interaction of humans or animals when trodden, cut or pulled, and by wind, sun, snow, frost and rain. Discovering this detail was only possible due to my repeated visits and the time to stop and look.

Divergence away from the designated path is sometimes called a 'desire line', a term coined by town planners to describe the natural route for the public to cut corners. The phrase intrigued me and it became the title for a new five-part work depicting stitched grasses. Removing the needlefelt, made with merino wool and plant fibres, from the original frames enabled me to turn them around, and the composition transformed into the shape of headland and sea.

Above and opposite: Details from Desire Lines *(see also pages 54–55).*

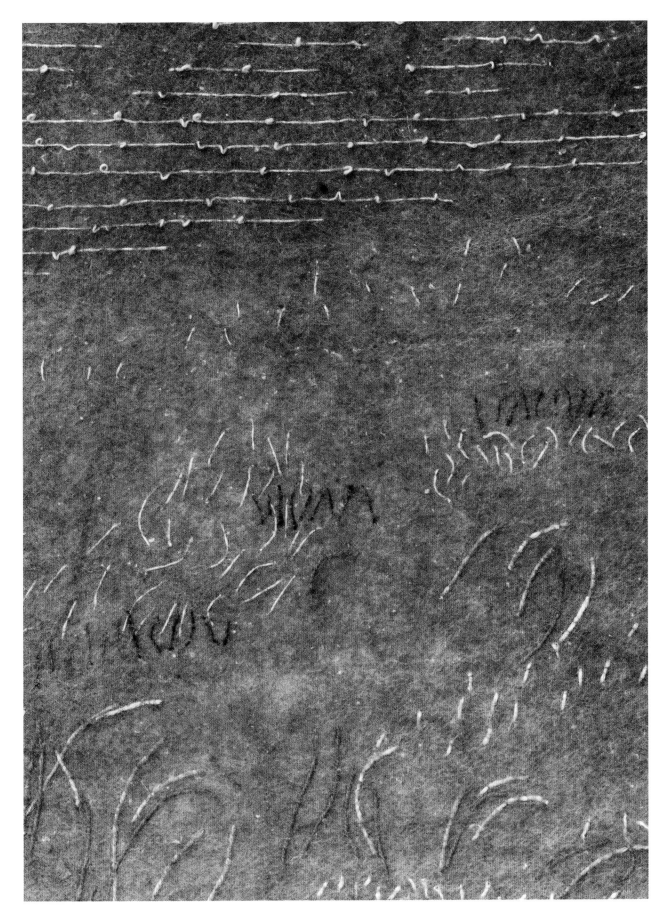

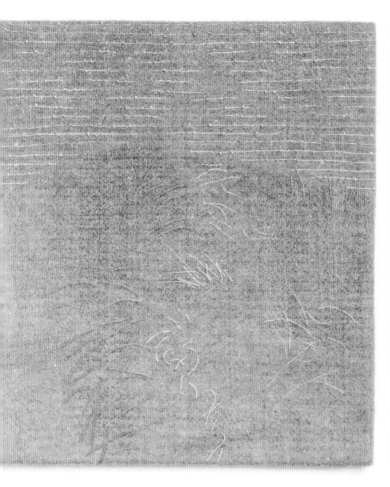
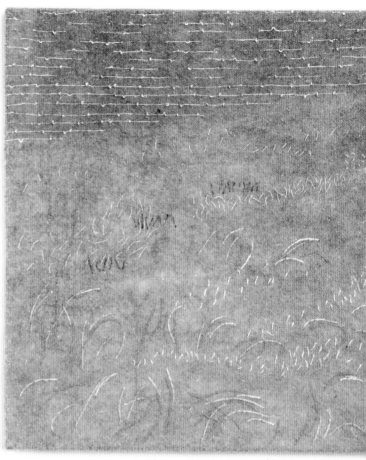

Desire Lines *(2021), four works, each*
46 x 50cm (18 x 19½in). Reconfigured
work with surface stitch.

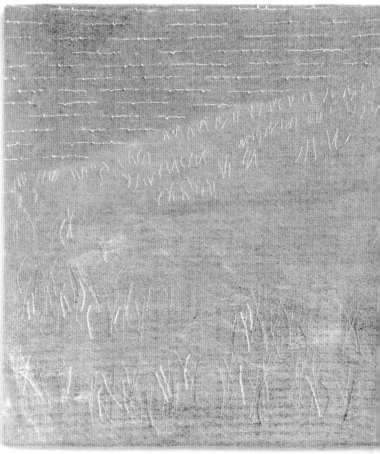

Various thread types, colours, stitch lengths and directions were considered to record the different grass marks. They were mounted onto another set of stretchers that unintentionally worked well in a line, resembling the pauses between each view on the headland walk.

Amazingly, there are 12,000 species of grass in the world and they are now seen as a valuable source of protection as cover plants for erosion control and removing carbon dioxide from the atmosphere. The tiny root hairs absorb water, trapping dust to help our lungs breathe easier, cooling themselves and the surrounding space (as with the scales on fibre which absorb the water when felted to create a protective cloth). 'No Mow May' in 2022 encouraged gardeners to leave lawns uncut to allow the natural flowers hidden below to grow, and enabling insects and bees to flourish. A growing appreciation of what grass offers both for wildlife and for human health and wellbeing is spreading throughout the world.

Bonding Memories

'I came from a family of repairers. The spider is a repairer. If you bash into the web of the spider, she doesn't get mad. She weaves and repairs it.'

Louise Bourgeois,
French-American artist

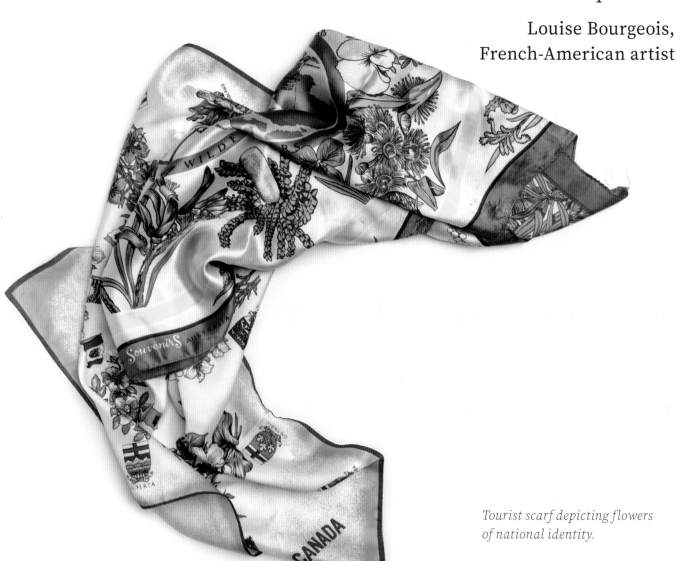

Tourist scarf depicting flowers of national identity.

Memories and stories of cloth seeped into my childhood in the countryside and continue to enrich my adult world. The philosophy from my thrifty parents to respect materials and nature were a normal everyday occurrence of self-sufficiency and survival. My mother's creativity was constant, unravelling, unpicking and remaking clothes discarded from aunts and uncles with their personality still clinging to the touch. Patches from dresses belonging to my mother and aunt, the dual lives of sisters, are stitched into a patchwork quilt that I treasure.

It was interesting to read the English writer and current Poet Laureate Simon Armitage's piece 'Lockdown' using this notion of textiles holding the history of a previous pandemic in the 'warp and weft of soggy cloth'. A bale of damp cloth from London was opened by a tailor's assistant and hung in front of the hearth to dry, releasing the plague fleas from London that spread throughout the small village of Eyam, Derbyshire, in 1665. This historical event was reawakened by Covid-19 with the memory of loss and disease contained within the cloth.

The Louise Bourgeois exhibition 'Woven Child' at the Hayward Gallery, London, in March 2022 enticed me out of the safety of home just as the pandemic was lessening. The sculptures used second-hand cloth and stitch and I was moved by the artist's words printed on the wall:

'These garments have a history, they have touched my body, and they hold memory of people and place. They are chapters from the story of my life.'

Bonded pieces of worn cloth transformed into textures.

Cloth holds memories

How cloth holds the memory of people and place has always fascinated me, and that is why I have used second-hand cloth in various ways and for various reasons in my work.

Open-weave fabric can bond into a felt structure as the scales on the fibre can push between the woven threads of the cloth. Repairs can be made by bonding the pieces by felting together and the worn cloth can be transformed into textures. Throughout my travels I have regularly searched charity shops and found many scarves that were ideal to use for this technique. Nature is often depicted with patterns of leaves and flowers, or land in the form of tourist sites, designed as a souvenir object of memory and nostalgia.

Left: Sketches: The Sun That Divides *(2012), 170 x 170cm (67 x 67in). Hand surface stitch, tourist scarf. Photographed by howaboutdave.*

Below: Detail from Sketches: The Sun That Divides.

One Australian scarf carried specific associations with national identity and colonialism, positioning aboriginal figures next to colonial images, totally distorted in scale. The individual vignettes were cut and separately embedded in small pre-felts before fully felting them into a larger square format. Loose lines of thread were spread over the surface secured into tree shapes, suggesting my wanderings through the bush sketching eucalyptus trees.

The anthropologist Tim Ingold discusses the rhythm of stitch and walking in his book *Lines: A Brief History*:

> *'Thus the hand writer is like the embroiderer of running stitch, whose thread continues even though its appearance on the surface takes the form of evenly spaced dashes ... like the walker, who does not cease to walk as he lifts each foot alternately, from the ground.'*

The finished work, *Sketches: The Sun That Divides*, depicts views of a first-hand authentic experience in contrast to the stereotypical clichés associated with a specific location forming preconceived expectations. It explores how landscape has become a commodity, with commercial profit dictating how we should regard land and nature rather than finding our own relationship to and appreciation of it.

The symbolism of white cloth

There are many examples of white cloth being used in rituals and as symbols in different cultures throughout the world. An interesting and informative article by researcher Rozaliya Guigova describes the ritual of using a large square white cloth in a Bulgarian wedding. The newlyweds walk on a cloth 'path' during the ceremony, and it holds fertility and protective qualities through their rites of passage.

A white cloth is also used for the final passage in life, as Jeeun Kim describes in 'The Usage and Symbolic Meaning of a Length of White Cloth Used in Shamanistic Rituals for the Dead in Korea'. There is a fascinating ritual of the *Kut*, where a figure representing the deceased cuts the cloth with their body by walking through it, to symbolize passing into the other world.

Felted white cloth.

59

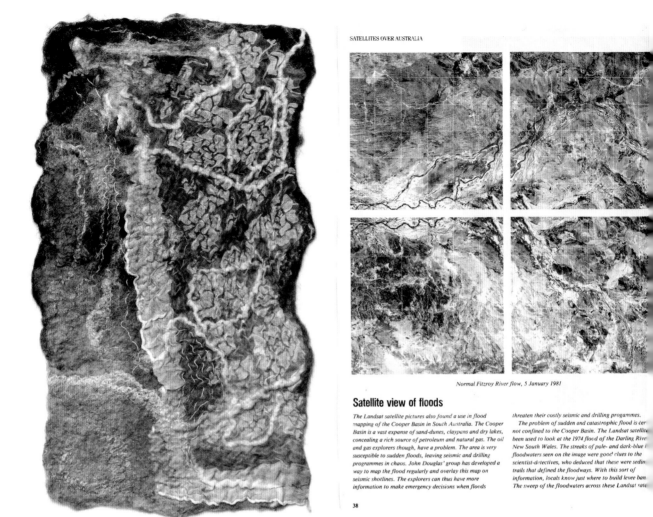

National Geographic *magazine and samples.*

The purity of white cloth clearly shows when the different surface texture of each cloth type transforms through the felting process. There is a contrast between fine chiffon, which shrinks with the wool and lays flat, compared to synthetics, which bubble up as the shiny surface creates a resist.

My early experiments with this technique began in my friend and artist Liz Jeneid's studio on the Illawarra coast during a week's rest between travelling and teaching in Australia in 1998. I was enjoying listening to *ABC Radio* when a report on salinization began describing the white-encrusted landscape, some of which was caused by the over-production of Merino sheep. It immediately changed my view of the cloth and wool I was using, realizing this now held a message of drought and loss of land. It also guided my choice of fabrics on my next visit to a charity shop, which produced two new pre-felt samples in another kind host's workspace.

Fitzroy River in flood, 22 March 1983

are a record of the huge flood of the Fitzroy River,
Australia, in 1983. With information from the NOAA
as well, and from aerial photos, Henry Houghton of
Australian Department of Lands and Surveys was
ace the movement of the floodwaters. This
ge of how the flood developed was used to determine
st to locate levee banks and other flood mitigation
.

ork was just one of the many ways in which Henry
n has used satellite pictures. For instance, he looked

at the spread of algal bloom down from the Peel-Harvey
Inlet, at the land use patterns across the Darling Range, and
at wind damage in the south-east wheat-belt. Certainly the
variety of tasks for which the orbiting space robots can be
used seems limited only by the resourcefulness of the
operator. Australians have shown themselves ready to adapt
the brightest and best of overseas technology to a whole range
of novel applications.

Note: All photographs overlap.

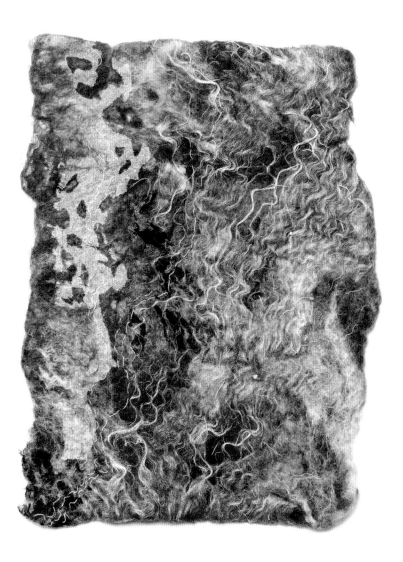

Further along the journey, another charity shop offered *National Geographic* magazines
with interesting articles about the movement of rivers, the opposite of salinization,
building my references on nature's precarious situation. In preparation for my next
workshop, I placed the recent sample and images together for possible inclusion in
the talk. I was surprised to see the similarity between the samples and the magazine
pictures, almost as if I had copied them. A travel line of choices and selection of
materials and images was informing the work in progress, formulated on the move,
in an appropriately nomadic process.

Emotional memories within cloth have always been strong, influenced by my mother's
obsession with collecting and hoarding fabric ready for the moment it might fill a need.
My mother developed this habit as a result of post-war rationing and having little income,
but I have no excuse, other than my love of unusual weaves and patterns, specifically of
the 1950s, holding a social history of inventiveness, style, people and place.

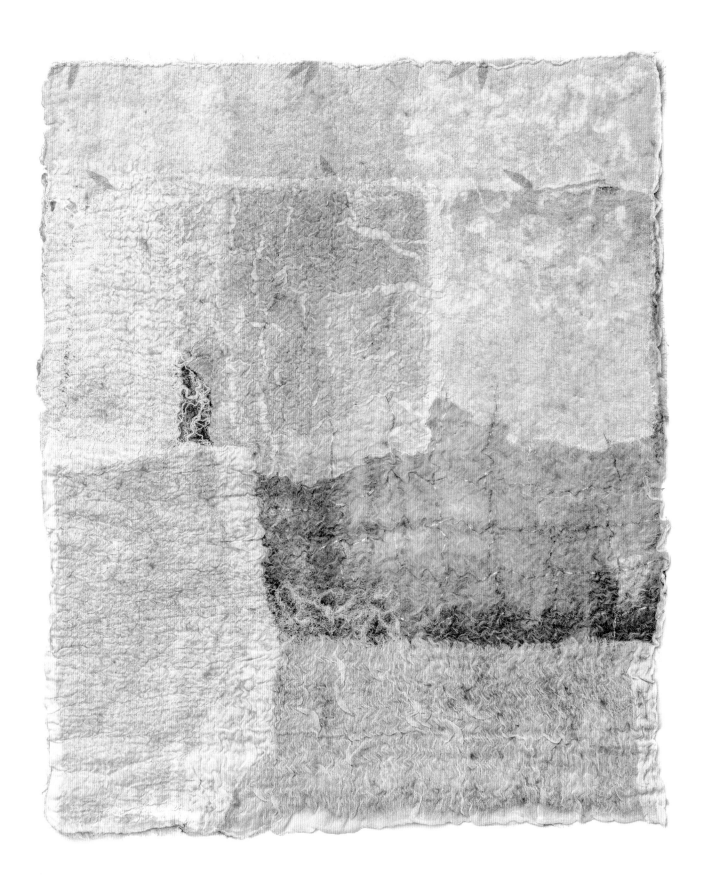

Early experiments in Australia, 1998.

Making Fast Fashion Costs the Earth *in the studio (see page 67 for the finished artwork).*

In 2021, I began new work for an exhibition specifically to consider the effect of textiles on people and place. Initially I was considering the effect of tourism, using my tourist scarves that depicted local sites but had been made elsewhere, mostly in China. But it would not develop, possibly because I was no longer travelling and had no emotional link with the idea. The climate crisis was dominant at the time of the pandemic and this issue was constantly discussed.

As soon as I read the statistic that it takes 1,800 gallons of water to make one pair of jeans, in an article in *The Guardian* titled 'Fast fashion costs the Earth', I knew this was my new direction. It emphasized the effect of textiles on people and place to change fashion trends and consumption, but it also evoked an image of drought and parched land. Instantly, these two concerns created an idea to felt and transform a cloth to resemble cracked earth. I had stored a beautiful old silk lace wedding dress for 40 years waiting for the moment to use it in the right context.

> *a precious garment*
> *worn one day stored for many*
> *a silken memoir*

Once the silk lace from the wedding dress was felted, a decision of where to cut had to be made. The shock of cutting into a perfect surface of felted lace echoed the shock of the deadly disease cutting off our lives from our family and friends. The direct strong mark seemed to reflect my anger at the lack of urgency of world leaders towards the climate crisis.

Cutting and Repairing

'A thing is always itself and more than itself.'

African proverb

Various artists have cut into cloth for different effects and meanings, transforming the feeling and quality of the surface and form. The American Minimalist artist Robert Morris has been a major influence. His work during the 1970s was characterized by the use of ephemeral materials to create an 'anti-form', experimenting with heavy industrial felt and textile waste products in an effort to dematerialize the object. His razor-cut marks into the felt produced a line that gravity opened into a form when the piece was hung on the wall. This emphasized what the direct and pure quality of the cloth was portraying rather than the making process through the hand of the artist.

Opposite and below: Detail from Veiled Land: Coded Site *(see also pages 66–67) and sketchbook.*

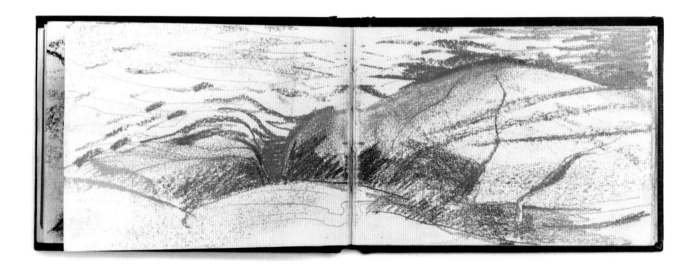

Cut slits were the main feature on a series of works selected for the touring exhibition 'Art Textiles II' in 1999. They suggested a barcode, a symbol of materialism and the commercial view of land. Peering into the slits revealed a layer of colour under the tonal surface of bonded stitched white fabric, referencing its use to advertise specific sites like the red sandstone monolith of Uluru in the 'Red Centre' of Australia. The slits were achieved by adding fibre over a plastic resist under the

main felt, creating a space to cut when fully felted. Piecing different qualities of white fabric to create different surface textures was an extension of the samples described in Chapter 3. The machine-stitched lines were copied from enlarged drawings in a sketchbook produced on site while visiting an island in Norway. The title, *Veiled Land: Coded Site*, refers to how advertising conditions our expectations and hides the true consequences of its effect on the environment, the white transparent cloth evoking the misty veil on land obscuring the reality.

I first cut into felt in sheer desperation to achieve a clear sharply drawn line when no sewing machine was available while travelling. You can make the cut line vary in width and definition depending on the position of the scissors and the cloth. Making on the move provided me with lots of problem-solving and the adaptability to seek alternatives, which extended my skills and perception of the process and ideas.

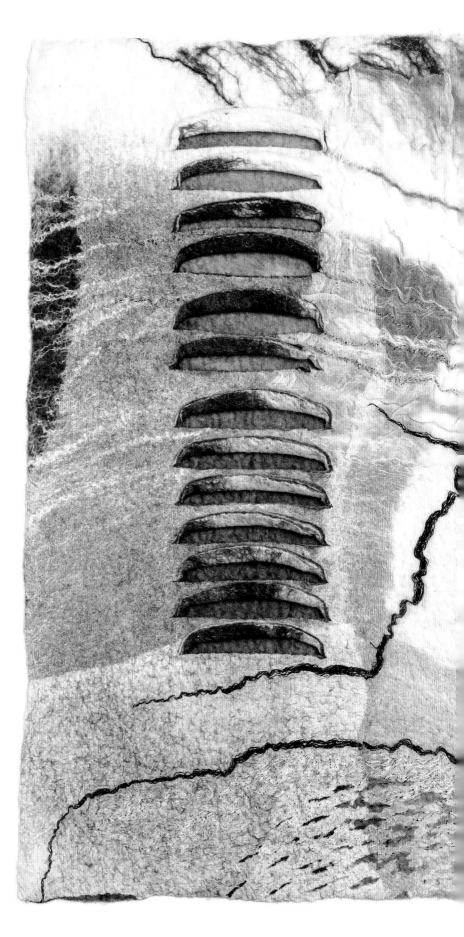

Veiled Land: Coded Site *(1999), 67 x 47cm (26½ x 18½in), one of eight panels. Selected for 'Art Textiles II'.*

For the work *Fast Fashion Costs the Earth*, I needed to ascertain the definition of the cut to produce the desired effect, especially from a distance. To create this distressed mark, I explored different techniques to construct various types of incisions into the surface:

A

Cutting into pre-felts and adding wool between on a thin layer of fibre before fully felting, which created soft cracked edges.

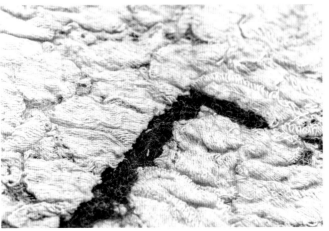

B

Cutting into the cloth on the surface of the finished felt, which made a ragged edge exposing the felt below.

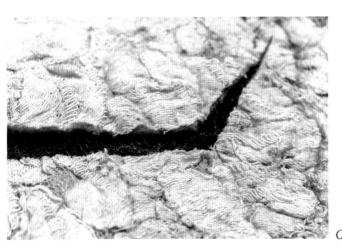

C

Finally cutting right through the finished felt completely and stitching onto a fully felted layer behind, which gave the strongest dynamic mark.

Above: Fast Fashion
Costs the Earth *(2021),*
106 x 92 x 2cm
(41¾ x 36¼ x ¾in).
Photographed by
howaboutdave.

Opposite: Cut samples.

The shape and number of cut lines had to be decided between
a few sharp clear shapes or more for an overall pattern and a less
severe image. To help this decision, thin lengths of black wool were
laid on the cloth and pinned in different compositions, checking
the spaces in between within the area of the frame. Using just a few
crack lines and method C (outlined opposite) for the sharpest edge
created the strongest impact of cracked land from a distance. The
lines also resembled burnt branches, an allusion to the mass forest
fires that had devastated Australia and other countries in 2020 – and
that are likely to continue in the future.

This project brought me back to making felt again. I was surprised
at how piecing together the skirt panels still held the memory of a
slim, petite figure that was transformed into an expanse of vulnerable
land, where the body seams became land lines. As anthropologist
Tim Ingold states, 'the worn is where humans leave a reductive trace
in the landscape'.

Mending the memory

Being from a fashion and embroidery background, I had always cut and sewn, so I automatically applied this approach when I first worked with felt. Building my own cloth enabled me to layer memories of place in the fibres and marks into the surface as a continual drawing process. This formed a direct connection to the environment of historical layers of land and agricultural changes of mass planting by 'shifting and stitching' the cloth, as alluded to in the samples I created. As the edges of felt are firm, it allows a freedom to cut and reassemble – for the interpretation and imagination to be in control, rather than the technique of construction.

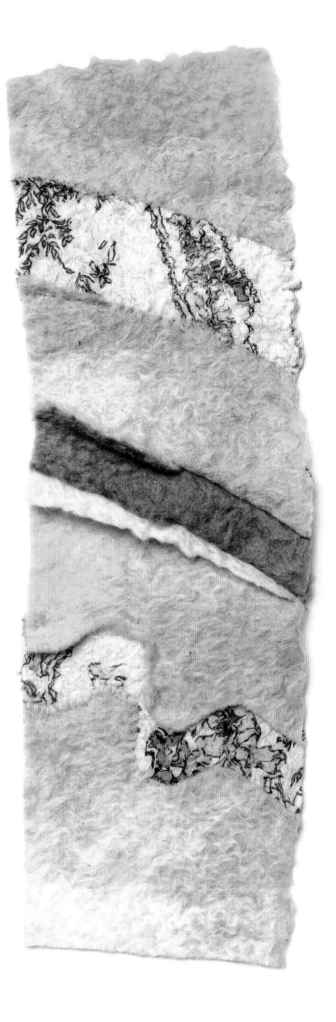

These non-fraying edges also enable you to explore the quality of line using different collage methods and stitch types. Varying the thickness of a drawn line will produce a three-dimensional effect; the same can be achieved by varying the position of a stitch along the joined edges. Over-stitching at the back of the seam and then gradually coming to the front will vary the texture of the line. You can change the direction of the needle through the material, either straight down and up to show the stitch, or at a slant to disappear into the thickness of the felt. Varying the type and colour of threads and the tension of the stitch can make interesting textured lines with no worries about frayed edges as they can be overlapped or buffeted together, either hiding or exposing the stitch will express a quality of mood to the composition.

A collage effect can also be made without stitch by using open-weave fabric that will bond when felted. Shifting and overlapping various pieces of old scarves for *Tracks and Traces: Alpujarras* suggested layered memories of the land surrounding my studio.

Opposite: Shifting and stitching sample.

Right: Shifting and overlapping open-weave fabric. Detail from Tracks and Traces: Alpujarras *(2010), 108 x 114cm (42½ x 44¾in). Various synthetic and natural fabrics, tapes and threads.*

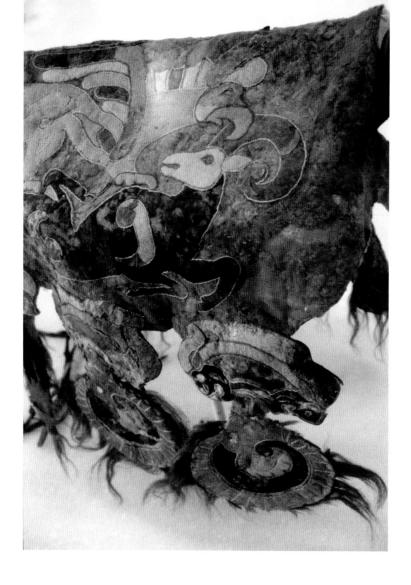

These techniques were initiated by visiting an exhibition of traditional Russian felt rugs using an inlaid appliqué technique, which inspired me to cut and swap shapes. (This was before I knew about pre-felts and felting open-weave fabric to the felt.) Years later, I was privileged to see a huge collection of amazing inlay appliqué felt rugs, animal coverings and clothing on a research trip to the Ethnographic Museum and the Hermitage in St Petersburg, Russia.

I was in awe of the large Pazyryk felt from around the 7th–2nd century BCE that had lined the tomb of a nomadic warrior, protecting and portraying his story by appliqué felt. Miraculously, the cloth had been preserved by the frozen conditions in the Altai Mountains of Siberia. From researching and using the traditional inlay technique, I now find its cut and reassembling structure has the potential to express the destruction of land and its need for repair and protection.

The opportunities for travelling to teach and exhibit have exposed me to different historical collections of textiles, many significant to a national culture and identity. This was apparent when visiting the Sapporo Museum in Hokkaido, Japan, to view the collection of boro-mended garments strengthened by patching to survive poverty, often stitched over and over through generations. Originating in rural Japan between 1850 and 1950,

the term boro mending, meaning something tattered or repaired, is derived from the Sanskrit word *borob*, referring to a special type of rice cultivation. The term also refers to the materials, which are all grown and processed on the land where they lived: cotton, linen, hemp and indigo for dyeing. The repeated running stitches would create interlocking patterns, many stylized from nature, called *sashiko*, which means 'little stabs'. These were traditionally objects of thrift, and were previously seen as a reminder of the embarrassment of former poverty, but are now exhibited in recognition of an ancestral pride of community survival and designated as important Tangible Cultural Properties. A distressed cloth is now displayed as a national symbol of pride, using the produce that the land provided for survival and protection.

After we visited the Sapporo Museum, my host drove us in a snowstorm to a second-hand shop. As it has officially closed for the day, I was able to creep around the silent store in low light. It was stacked with objects depicting the Japanese way of life, and I became immersed in past rituals and traditions. Conversations about cloth and kimonos were exchanged and translated as we snuggled up on cosy old armchairs around a traditional fire with green tea stewing above. The love of cloth is worldwide and friendships form instantly through shared knowledge.

Shared stories and often painful memories are expressed by the sculptor and artist Louise Bourgeois, as mentioned in Chapter 3. Her work was influenced by early memories of working in the family-run tapestry restoration studio. Reassuring words by Bourgeois were printed on the wall of the gallery. We are invited 'to reimagine the meanings of mending, including a concept of emotional repair that – rather than neatly sewing everything up – can expand and refresh our perspectives.'

Darned worn Japanese fabric.

Narrative and cloth were a consideration for the Stitch and Think project initiated by Janet Haigh and Dawn Mason in 2008 to discover the practical and philosophical use of stitch in the process of making. During workshops and interviews with a group of makers, a focus of darning and mending emerged, considering 'the wide range of uses for stitch as a visual language'.

Ideas around the philosophy behind extending the life of a cloth developed, suggesting 'Rupture and suture is a language of mending the body, cloth once protected the body.'

The exhibition, Mending at the Museum, displayed the results of these conversations with the realization that 'the tactile and haptic knowledge that manual skills allow by direct sensory perception has a profound alteration in our ability to connect and respond to the world around us.'

This has become even more significant since the pandemic, where much research and reporting have shown the importance of managing one's emotions and ability to adapt and rethink one's approach to uncertainty. A creative action could focus one's mind so the inner feelings can respond to the external problems.

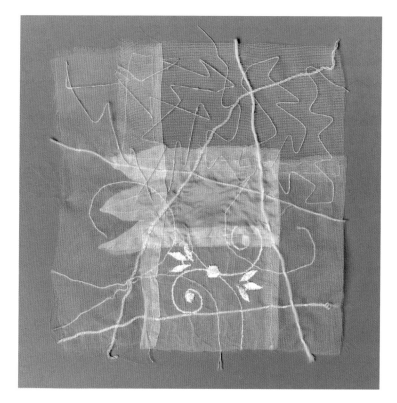

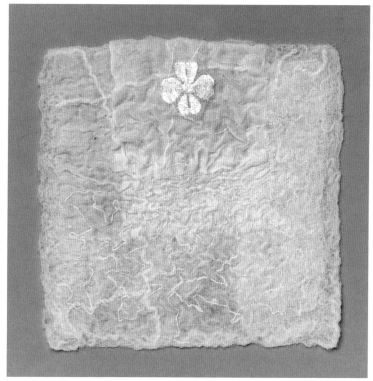

Samples inspired by Japanese darned cloth.

Cloth as protection

Felt is one of the oldest forms of fabric used to protect humans, for clothing and dwellings. The nomadic life requires a portable structure with natural materials created from the land, not owning the land but borrowing a space. I saw no fences or any signs of ownership while travelling in Mongolia and the land was noticeably free of rubbish.

Travel has shown me many examples where cloth protects land and nature, such as wrapped trees in Japan against the frost. Or long lines of fabric draped over grape vines in Australia, and cherry trees in Norway to prevent birds harvesting the fruit.

Different cloths are used for various reasons, even in research, for example to protect plants from cross-pollination at the John Innes Institute. My grandfather made use of worn sheets and net curtains to protect his garden from the frost or birds. Now commercial growers need metres of specially made cloth for protection but open enough to allow the rain through.

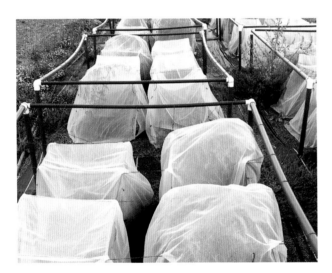 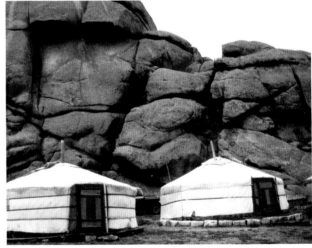

Browsing the internet, I discovered a business called Hortiwool, which advertised a 'natural nutrition, 100 per cent pure wool that feeds as it composts'. They are developing a range of needle-felted wool suitable for different uses in the home and garden, considering the environment and social impact. I was aware needlefelt had been used to protect land from the technician who worked the needlefelt machine at Huddersfield University. He had a business that produced specific mixes of fibres suitable for the needs of soil and plants, which would hold moisture, release nutrients and protect soil from erosion. I felt privileged to have spent time with him and shared his enormous knowledge and skill, as he would pick up a fibre, move it between his fingers and sniff it to identify its specific qualities.

Above left: Cloth covering plants to protect them from unwanted cross-pollination.

Above right: Felt yurts protecting internal spaces.

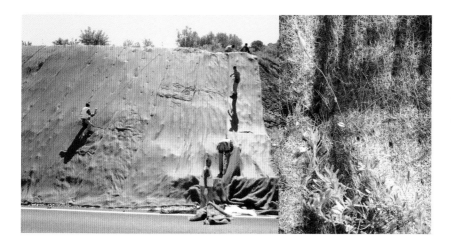

Left: Needlefelt covering landslides, with wild sweet peas returning the following year.

Below: *Stitched felted blankets from the Republic of Georgia.*

It was fascinating years later to see lengths of cloth being spread over the steep banks on a road near my studio in Spain. We had been steering around the landslides caused by heavy rain and I forced my friend to stop the car when we saw this unusual sight. As I approached I was delighted to see it was needlefelt and was told it was coconut fibre made in China. I had been upset by the loss of wild sweet peas that had grown all over the banks before the road was widened, but in the spring I was pleased to see shoots were peeping through the holes of the needlefelt: cloth and nature as one.

During research in the Republic of Georgia, we were shown local felted rugs but we also experienced the unexpected, such as the sudden sight of moving stitched felt – horse blankets beautifully embroidered with love and hope. They had been made for the riders and horses of the Georgian army, who were protecting a constantly threatened and precarious landscape. The hand-stitched bold flowers used threads spun from local wool and dyed with plants from the land, a natural connection between person and nature.

Textile artist and curator Clare Hunter confirms in her book *Threads of Life* that the tradition in many cultures throughout the world embroidered textiles were considered as efficacious as a shield for protecting human beings in the world and the next:

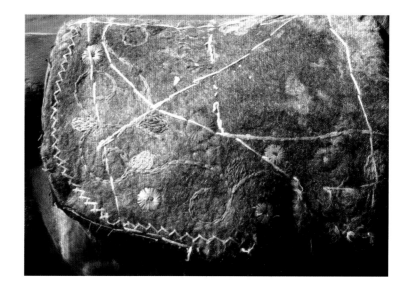

> *'Imbued by the force of nature – the plants from which dyes have been extracted, from which the thread has been spun – textiles provided a natural armoury to ward off attack.'*

Words as Inspiration

'To walk the same way through the same space the same way is a means of becoming the same person thinking the same thoughts.'

From *Wanderlust: A History of Walking*,
Rebecca Solnit, American writer

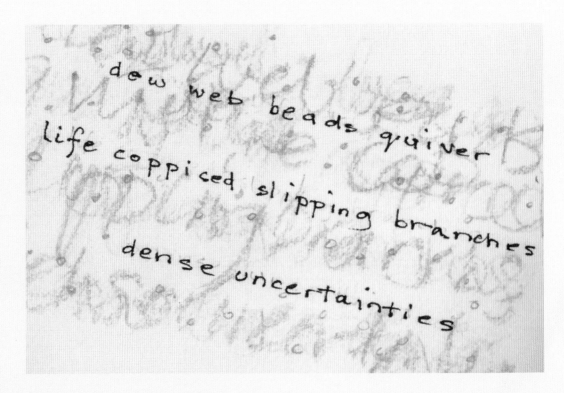

Playing with words (detail).

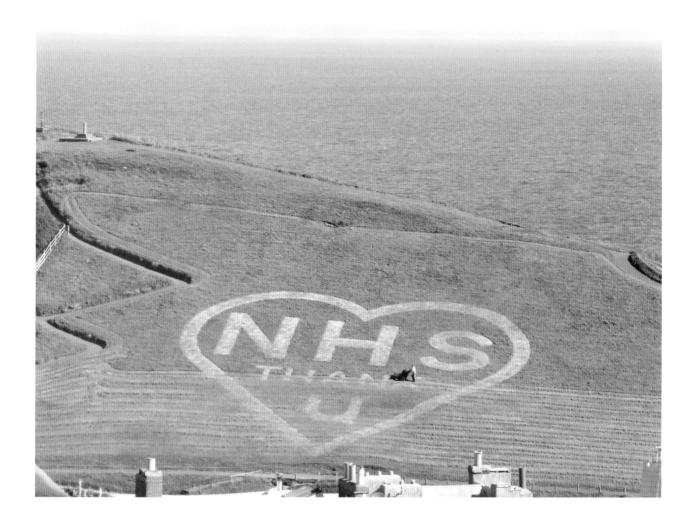

Messages and memorials

Above and below: Words mown and written on stones.

For someone who failed with words at school, due to partial dyslexia, I was surprised how important words became during the isolation of lockdown. They may have replaced the lost spoken words and listened conversations I had with people, creating an internal dialogue as I walked the repeated rhythm of my steps.

The pandemic produced a profusion of personal messages declaring love and encouragement chalked on roads and on cloth in windows. A thank you to the NHS was even mowed on Capstone Hill in Ilfracombe, a community sharing and speaking their thoughts and thanks. Gradually, as the weeks progressed, words of loss appeared on labels tied to flowers on benches or a shrine of objects, or asked you directly to 'skim a stone for Kelly'. The many and various emotional words touched me deeply and influenced how I began to respond to a place in a very different way than before.

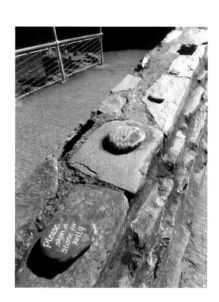

Words given or sought

During lockdown, I was recommended 5x15, an online spoken-word event that brings together leading figures to discuss ideas and develop inspiration. One session, 'A World in Transition' concerned a 'living language': 'A journey through endangered and minority languages that reveals different ways to relate to land and nature'. The discussion centred on how language helps us to understand our environment and to live sustainably. When language emerges from a specific place there are often no nouns but only verbs to express emotions and not objects. How we speak gives us a better understanding of and connection to the world around us; in losing these words we lose a way of seeing.

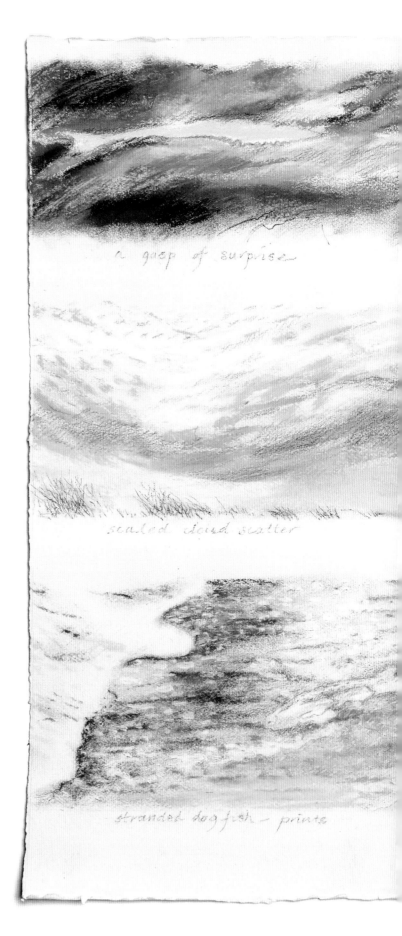

Pastel drawing influenced by haikus (2020), 76 x 56cm (30 x 22in).

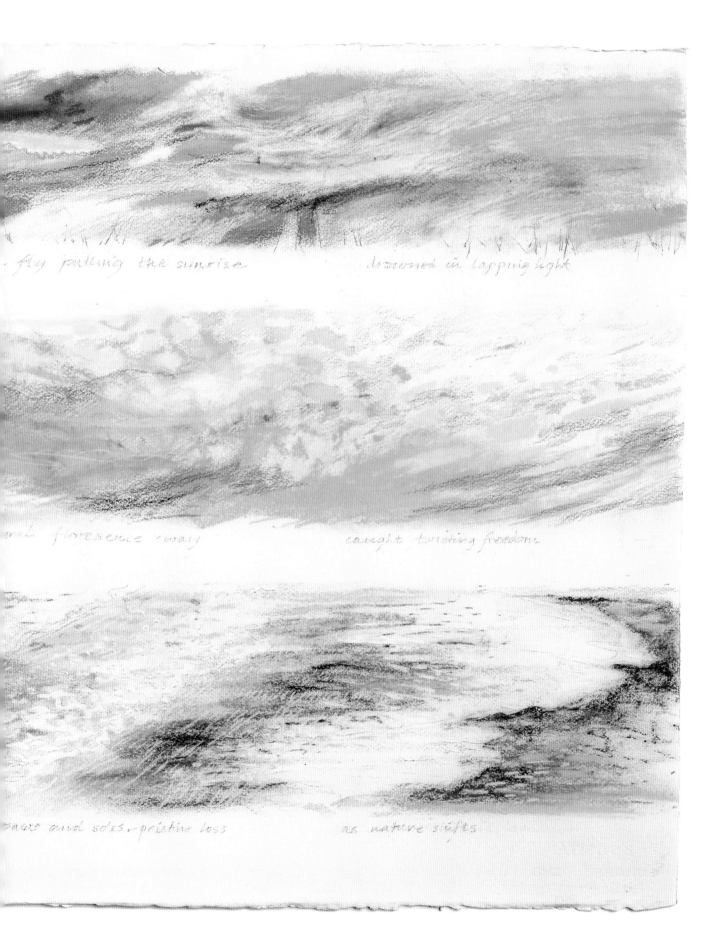

fly parting the sunrise drowned in lapping light

red florescence away caught twisting freedom

peace and soles - pristine loss as nature sifts

Words would suddenly sound in my head rather than from my mouth of how I felt rather than what I was seeing. A smell or sound triggered memories and often linked with phrases I had read recently. But how would this collection of the mundane become an important action for ideas to evolve towards a creative art form? Fortunately, this was answered by an invitation to join an online haiku workshop with Creative Beings, based in East Devon.

Haiku had fascinated me for years, and this would be an opportunity to select words that had been scribbled or typed. The excellent tutor set a calm structure and pace that gave me confidence to try something that terrified me because of my literature failures at school. This fear lessened when I realized that my aim was not to write a perfect Haiku but understand how its 5–7–5 structure began to inform the selection and process of looking at nature, my photographs and drawings. It expanded the visual experience of drawn marks with the senses, to include words of smell and sound within time and place.

Playing with words.

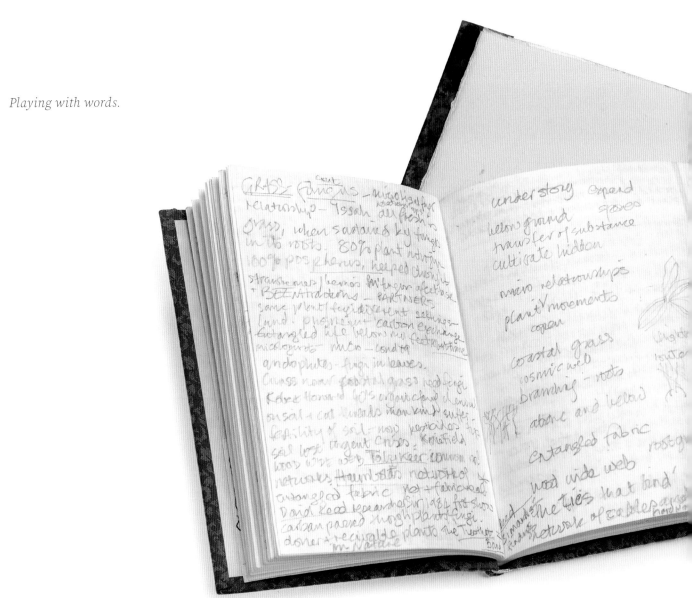

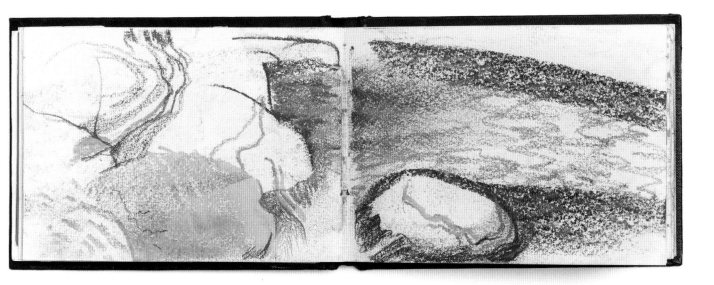

Sketch of stones on an island in Norway.

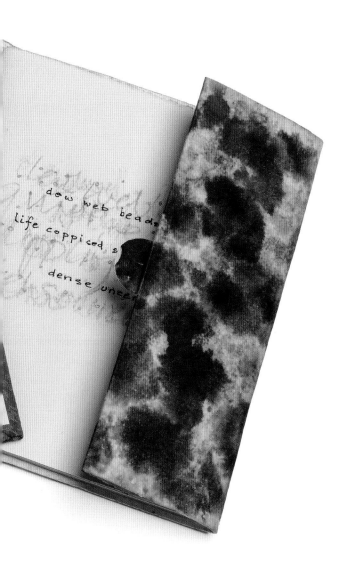

I appreciated the different relationships words had with indigenous people. For example, a stone can be seen as holding a memory of the past, creating a specific kind of relationship with the land.

Considering the different uses of words gradually guided a direction of looking and in turn influenced what to research and develop in terms of a new theme and focus.

Installation in Art Life Mitsuhashi Gallery (2002), Kyoto, Japan, 19 x 186cm (7½ x 73¼in). Photographed by You Kobayashi.

Collaboration and dialogue

Listening to the 5x15 discussions and having Zoom calls with family and friends during lockdown helped to replace the dialogue I was missing through encounters while travelling and teaching. However, it was not the same as direct face-to-face contact within a specific environment to appreciate and learn from other points of view and responses to your work.

The international projects I have been fortunate to participate in were very beneficial in expanding my approach to perceiving ideas and acknowledging my cultural difference. This was a key experience in the Felt Crossing Borders project that began in 2000, when I (from the UK), with my friends and fellow textile artists, May Jacobsen Hvistendahl (Norway), Lene Nielsen (Denmark) and Jorie Johnson (Japan), initiated a cultural and creative exchange programme. We worked and exhibited in each member's country to explore our common aims and cultural differences through dialogue and the making process. A theme chosen by the host provided four different interpretations and approaches to experiment with new fibres and different methods of construction. In Japan I experimented with the traditional technique of shibori, producing a floor work of carpet-weight felt inspired by the environment.

Directly after participating in this special project, I embarked on my solo show at Huddersfield University as an artist in residence in 2006. Inspired by the importance of dialogue, I contacted the plant scientist Michael Ambrose, the Genetic Resources Unit Manager at the John Innes Institute, to expand my language and my perception of plants in the environment. He was very generous and knowledgeable and was sympathetic to my approach with textiles as I was guided to the various research sites within the institute. It was interesting to see the use of cloth to cover and protect plants in the research garden to prevent cross-pollination (see page 76). During one of our insightful conversations, he stressed the importance for a scientist to develop an acute eye to see slight and minute differences. His term 'a variation of a trait' became the title of a set of felt works in which I changed the sequence and proportion of plant fibre with the merino wool. These new subtle textures were how I was seeing nature now, with slight changes of texture and colour across fields changing in the seasonal light.

Shibori tie-dye.

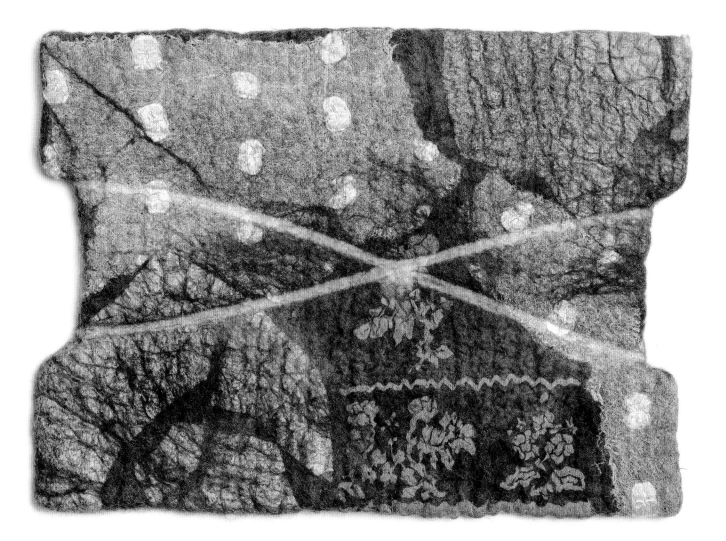

Words from literature

I am fascinated and inspired by how authors use words of stitch and cloth to emphasize emotions between the body and landscape. A beautiful and powerful example is found in Anne Michaels' 1996 novel *Fugitive Pieces*, expressing loss: 'I tried to embroider darkness, black sutures with my glinting stones sewn safe and tight, buried in the cloth … memories of people lost … Black on black, until the only way to see the texture would be to move the whole cloth under the light.'

Light and dark is also explored in *China Room* (2021) by Sunjeev Sahota: 'Above him, the stars are bright and stitched into the day's dark dress'. Reference to the body and nature is suggested in *The Conjuror's Bird* (2005) by Martin Davis: 'She moved easily and lightly through the long grasses, slipping between sun and shadow like a white thread stitching the trees to the meadow.'

Stitched stars and shadows steeped in the atmosphere of time and place evoke the depth of loss that the pandemic had caused. The repetitive action of stitch suggests a space of time and patience for the recovery of loss, the tactile experience and visible substance of cloth and nature.

American writer Rebecca Solnit has often wished that 'her sentences could be written out as a single line running into the distance so that it would be clear that a sentence is likewise a road and reading is travelling ... (rolled up like thread on a spool)'.

Words are an important component of the making process, linking internal and external thoughts to activate one's imagination and ideas. The pandemic saw an increase in the number of books and articles written about nature and wellbeing, informing us of the astonishing discoveries of its hidden wonders. This expands our understanding and perception of nature to consider our position in the environment as we travel towards an uncertain ecological future.

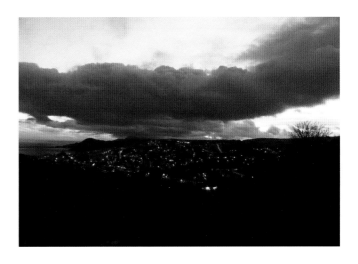

Above: Pass on through the dark landscape.

Below: Felt sample.

Gathering the Research

'The work of the eyes is done.
Go now and do the heart
– work on the images
imprisoned within you.'

Rainer Maria Rilke,
Austrian poet

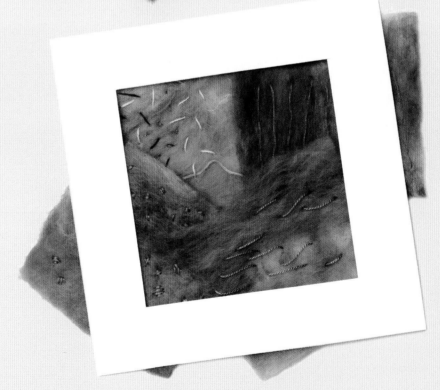

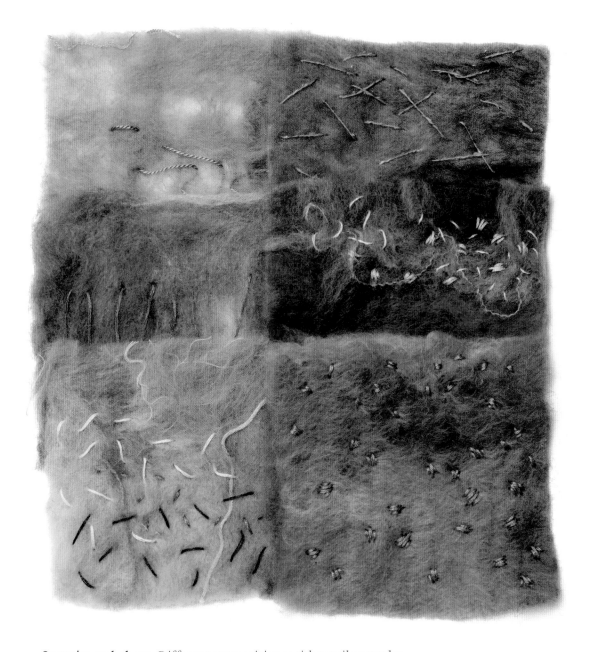

Opposite and above: Different compositions with textile samples.

Gathering the samples and images to discover their often surprising links and associations is one of the most rewarding parts of the creative process, as the imagination becomes heightened with new ideas and actions. But when do we know whether the idea is really our individual approach? As the American painter Georgia O'Keeffe (1887–1986) suggested, 'we only have one or two breeder ideas in our lifetime'.

Looking at old work, I often see a trait similar to current work, as I recognized after finishing a series of drawings in a barn. Not only did the space remind me of my childhood experience of playing in my grandfather's barn, but also the structure was like a relief sculpture I had made during my first year of art school.

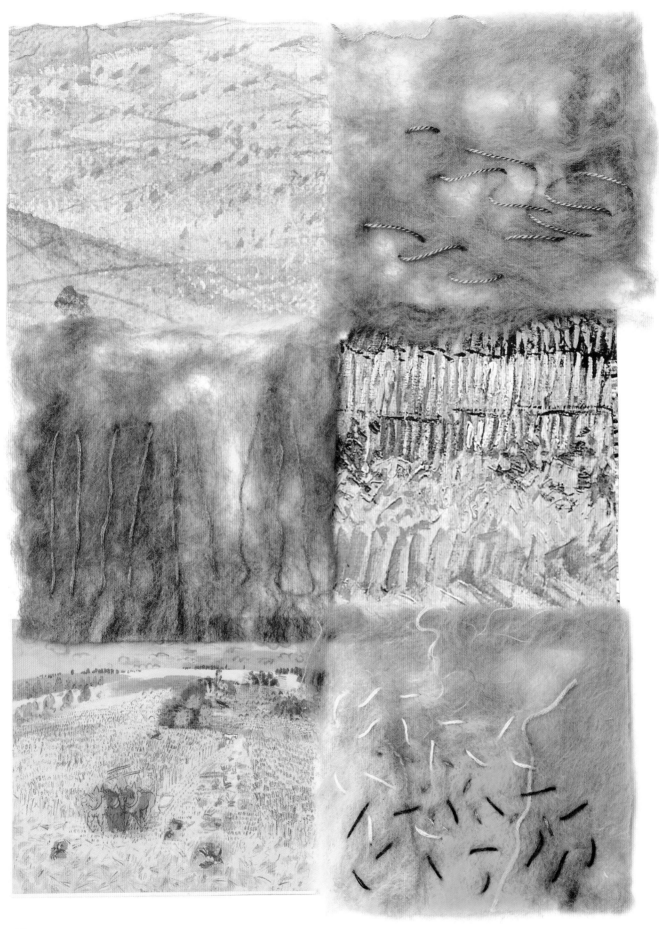

Selecting source materials

A good starting point is to select from your often separate piles of postcards, photographs, magazine images and discarded textile samples, usually from the bottom of a box or bag. Spread them out and enjoy moving them around until unexpected connections and distinct differences of colour, texture or form begin to show. Be prepared to trim an image or sample to emphasize these qualities.

Various activities need to be available to suit one's frame of mind and energy from mental fluctuations to contemplative attention. A mindless play session is useful to activate the imagination, like arranging discarded bits of fabric or felt on white paper, covering areas with a card mount and photographing the different compositions. You can print these out and add them to a new mood sheet, or you might find one that relates to your current project. The most important factor is that ideas are not instant; they take time to evolve, which is why it is easier if they are displayed on a wall or a large board. This enables the ideas to consolidate through contemplative attention and patience, which cannot be forced; give the material time to speak to you. Do not be afraid of making mistakes, as they are often the key to a new approach, and it is better to have tried than not. Pushing personal boundaries risks failure but it extends one's ability, achievement and wellbeing. We can learn from the process, even if the result is not what we hoped for, as it will lead to new ideas for future work.

Mood page of images and textiles.

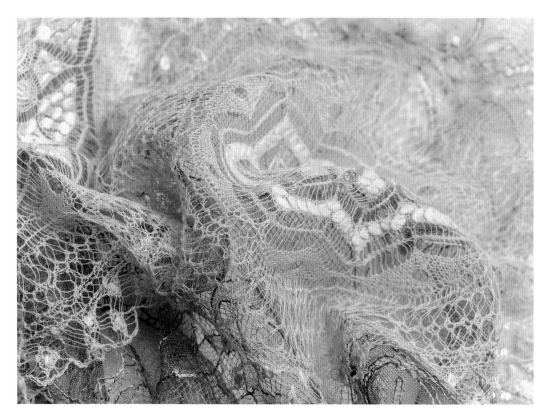

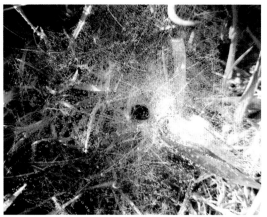

Scrolling through my photographs, I stopped at an enlarged image of spider's webs on low-growing grass. I now saw the abstract form as a textile with the fragile lines stitched with fine threads on a delicate base. This was the complete opposite to the solid thicknesses of thread and colour used to stitch the movement of grass on dense needlefelt. The webs also suggested the veiling I saw at the John Innes Institute, where open-weave cloth covered plants to prevent unwanted cross-pollination. These references were still in an old folder, which I removed and added to the new collection, highlighting another element of the theme and expanding the original focus.

Random words and phrases emerged: delicate lines in nature; tenuous stitch; veiling in nature and plant research; bonded lace and transparent cloth. This suggested a more delicate structure than the embroidered lace used for the cracked earth. Fortunately, I had my mother's small collection of old fine lace stored in a cupboard.

A few lace samples were placed alongside the spider's web images in the folder waiting for further connecting images and samples. Sometimes they lay fallow for a few months or years and were often used for a new project with a different title. As in life, we need to be flexible, open to changing direction but with the support of developed skills and ideas.

Allowing mental space

Now with the portable space of a folder to store ideas we also need a mental space and routine to be able to transform these ideas into completed work. Clearing one's head to occupy your mind with creative thoughts is not easy in a world of constant interruptions. My phone is switched off early evening and is not turned back on until after my morning walk, which provides me with regular reading and thinking time. A forward planner on the studio wall has coloured areas filled for dedicated creative time between other commitments. Deadlines are a necessity for prioritizing time to complete each stage of the process and eventually the work. This helps to prevent displacement activities creeping in and procrastination over one work or idea.

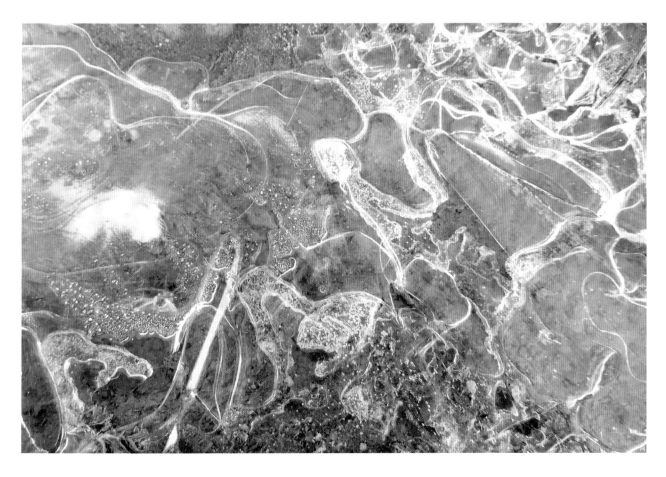

This approach was discovered after I felted a torn lace Victorian baby's bonnet I had discovered in a French junk shop. The experiment was to discover whether the lace would attach to the wool fibre and how its form would change through the shrinkage. The technique was successful, but the final shape was disappointing as there was no connection with a project or place.

Years later, an opportunity came to exhibit in 2005 at the Zoological Museum in Cambridge with the 62 Group of Textile Artists, and I knew exactly what I could use to suggest the encrusted forms of the museum's coral collection. The embroidered bonnets were at last defined for a place and purpose. With more felting, the tightly stitched motifs would resist the fibre and raise up to convey the textured coral surface.

Baby's bonnet and felted sample.

This technique also enabled me to make these small forms on the move due to a tight schedule of workshops, but how and where could I frame them? This puzzle was resolved by placing the pieces directly in the display case of corals, although they had to be deep-frozen first to eliminate any risk of contamination. To integrate them into the collection, labels were made defining their place and date of discovery, as with museum objects.

From the first failed sample to a successful conclusion seemed to illustrate the importance of process and patience. As the activist Satish Kumar suggests; 'Learn from it, not about it.' This work now has a different presence. The collection shows the protected examples of what is being destroyed by the heated and polluted sea.

Coral form.

Collecting ideas

Continuing the process of collecting ideas within the Covid restrictions, I resorted to finding opportunities locally to shift my apathy. I contacted Barnstaple Museum, and the museum manager kindly provided me with information on current local art initiatives and their first major textile exhibition, of the weaver Ethel Mairet, to be held the following year in 2022.

A quote from her, 'The way to beauty is not the broad and easy road: it is along difficult and adventurous paths', was printed on the wall where I was observing her stone collection. This reassured me to keep searching for a way forward both personally and creatively, possibly referring to a local journey rather than the opportunity for global travel that I had lost. I was fascinated by the trapped linear marks within the slate, hidden for years until inquisitive geologists reveal and collect them, with a persistent need to question and discover. I too was searching for something hidden that had been buried from feelings of fear, but knowing what questions to ask has always been difficult.

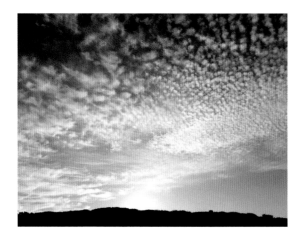 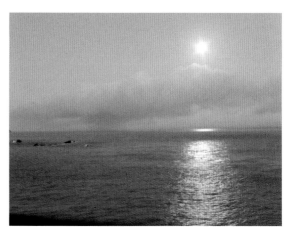

A few months later, I found some answers in the most unlikely place: a chapel in Exeter Cathedral, when I was not even thinking about my work. I had taken my grandson to see the Museum of the Moon displayed in the central nave. Away from the throng of excited children in a space specifically designated for quiet contemplation, a small card behind the door stated:

'Reflection'
Spend some time quietly looking at the moon ... the colours ... the shape ... the texture.
What surprises you?
What delights you?
What challenges you?

Although I didn't apply those questions to the moon at that moment, I saw them as a way to unlock my muddled inner thoughts to consider a new focus and direction, associated with the experience of nature and land. What surprised me was that although I delighted in nature, finding a specific linking element was a challenge.

Following a family ethic 'don't waste time', I have found it difficult to acknowledge thinking time as being just as important as making time, which is immediately visible. This caused frustrations during my fine art degree course, when I would spend all day just looking at an arrangement of objects and only moving something slightly. But gradually I realized I was considering the void, the space surrounding the form. This changed my approach towards textiles and eventually led to many exciting installation opportunities. Accepting that ideas develop slowly helped with the frustrations of lockdown, knowing that, with patience and trust, something would emerge.

When I was decluttering my house in Spain I came across an old children's book titled *Plants that Heal*, part of the Play Ideas series. Playing with nature was a common occupation in my childhood, when we had no television and lived in an isolated part of the countryside. The book covered plants from early medicinal herbs up to the modern pharmaceutical industry of that time, but now there is another story regarding the healing and destruction of nature.

Nature gave us aspirin from willow, for example, but human greed has led to mass production and reliance on drugs that have caused addiction and death. The climate crisis has emphasized the need to take back control of our bodies and nature, to consider the healing of both humanity and the planet.

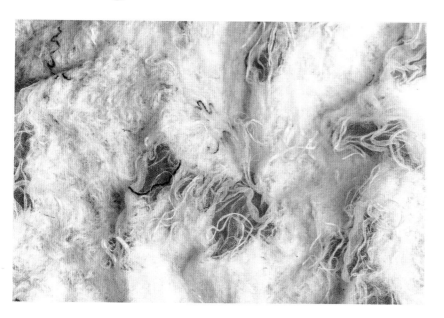

Ideas and associations began to form from the perspective of the hidden and healing, like mycelium for fungi and flower essences for humans. But how and where would fibre and felt relate to this idea? The question was soon answered: what was hidden in fibre was exactly why it bonds; when agitated, the tiny scales interlock into cloth. Felt has been made for centuries specifically to protect, its natural properties being used to repel water and add warmth. The material and technique took on a new emphasis to explore bonding hidden layers of thread and fabric, with the distortion of structure and form. I had become more discerning and inquisitive, spending time in observing things around me more deeply.

Opposite left: A local journey – a hidden moon.

Opposite right: Spend some time quietly looking at the moon.

Above left: Plants that Heal *book.*

Left: Bonding hidden layers of thread and fabric.

Essence

'Nature is always the same, but nothing of her remains ...
Our art must provide some fleeting sense of her permanence,
with the essence, the appearance of her changeability.'

Paul Cezanne, French artist

The key word that resolved a new direction was working towards an exhibition called 'Essence' and to consider what was the essence of my practice now. This challenge forced me to concentrate on the common core of my research and consolidate ideas so far for the hidden and healing of nature.

The idea of 'hidden' triggered a very early memory of experiencing how amazing nature is. I recalled being four years old and climbing out of a secure garden into an unknown field. My inquisitiveness led me to a fallen tree. I lifted the bark to look underneath; to my surprise and delight, hundreds of ladybirds began scurrying around to hide. This pivotal moment embedded the essence of my life-long fascination with land and nature.

These moments of insecurity heighten a state of alertness, which are often recalled to influence one's creative thoughts. When the Swiss sculptor Alberto Giacometti (1901–1966) walked through the woods to visit his grandparents as a child, he was scared of the tall figure-like trees, which later influenced the gaunt, linear quality of his sculptures.

I too was influenced by staying with my grandparents in Epping Forest, where the gnarled, pollarded trees became figures or creatures in my imagination. My grandfather was an estate carpenter and forester, growing food and keeping animal stock. This helped to create my sustainable ethos, as did the mending and making that went on in his workshop. I spent hours playing in the loft and peering through the slats of wood to the adult world below.

This image returned as I stood in another barn years later drawing the open structure, layering the pastels as if layering fibre. I was studying at Goldsmiths in London. I had just been introduced to making felt and had seen a yurt in the Horniman Museum. I realized I had found a textile technique that encompassed my concerns at the time, that of home and land ownership, rights of way and access to land. The nomads made the felt in the outdoors to cover their portable yurt structure that was erected on land that was not owned but borrowed. I was blessed to eventually see this process, the origins of my textile practice, as performed on the Steppes of Mongolia.

Above: Barn workshop of the author's grandfather. Photographed by Les Wilson.

Opposite: Barn drawing (1988), 80 x 58cm (31½ x 22¾in). Pastel and pencil.

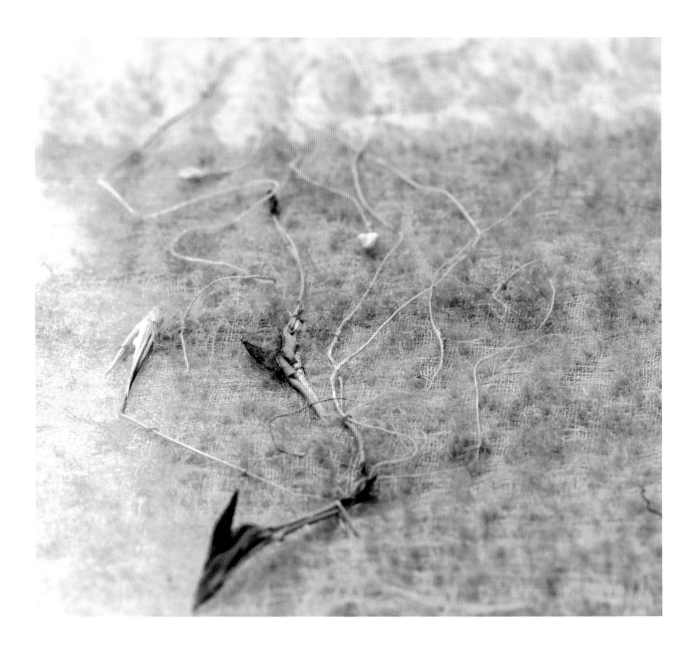

Hidden life of awns and scales

Reconsidering the fibre I had used for years, I was now focusing on the hidden role of the scales that cling and bond. This also happens in nature, as many plants have an awn, a bristle or hair that hooks together or embeds in the soil. This unique structure prevents them from reversing back out again, as with wool fibres, which cannot revert once felted.

When I was researching for my solo show in 2006, I had compared the barred felting needles to that of the wild barley growing around my studio in Spain. I used a few barley awns for an installation and appliquéd them on felt, but found this frustrating as they kept shifting backwards out of the stitch.

Left and below: Barley awns used
on felt sample.

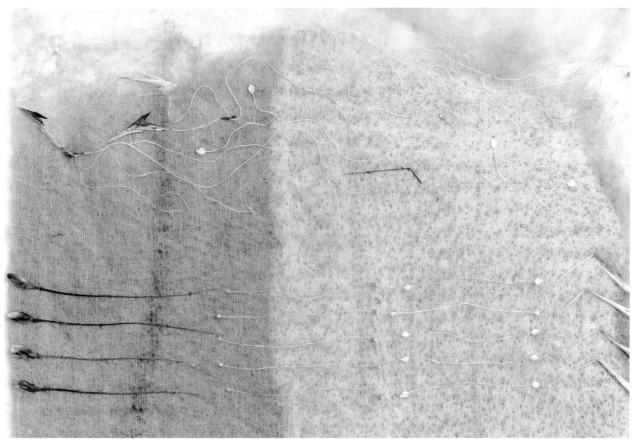

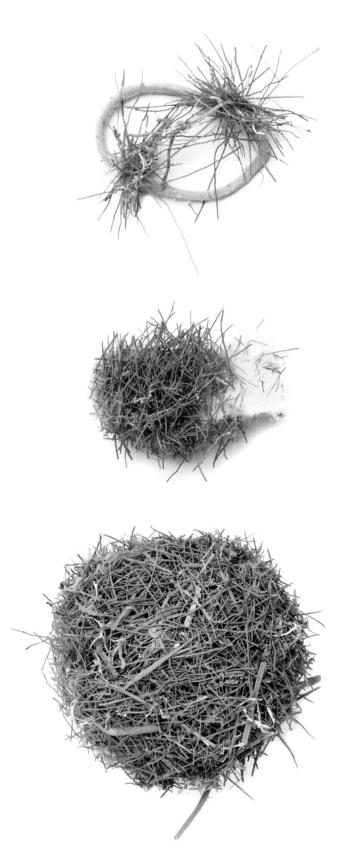

Plants are a fibre, and many seeds have scales that help with dispersal, such as the hair of the willow seed. Unlike a woven cloth, where you can see the interlocking threads, the action of agitating moist fibre is hidden once felted. This mysterious alchemy can be seen in nature where rough stems or grass interlock together through the rhythm of the sea or wind, similar to the felt-making process.

I first became aware of this phenomenon in Australia when I was shown a collection of firm, felted oval balls of natural fibre, found on the beach where the rhythm of the tide had gathered the stems and, over time, gradually increased them in size. Many years later in North Devon I came across the different stages of tiny stems attached to soft materials, one of which had become a complete large ball. These still remain on my studio wall, providing constant inspiration. I am a witness to nature's ingenuity in covering polluting material and transforming it into an object of beauty with the rhythmic power of sea and tide.

Left: Fine stems bonded by tide.

Opposite above: Fine stems tangled in fishing line by tide.

Opposite below: Grass felted by wind.

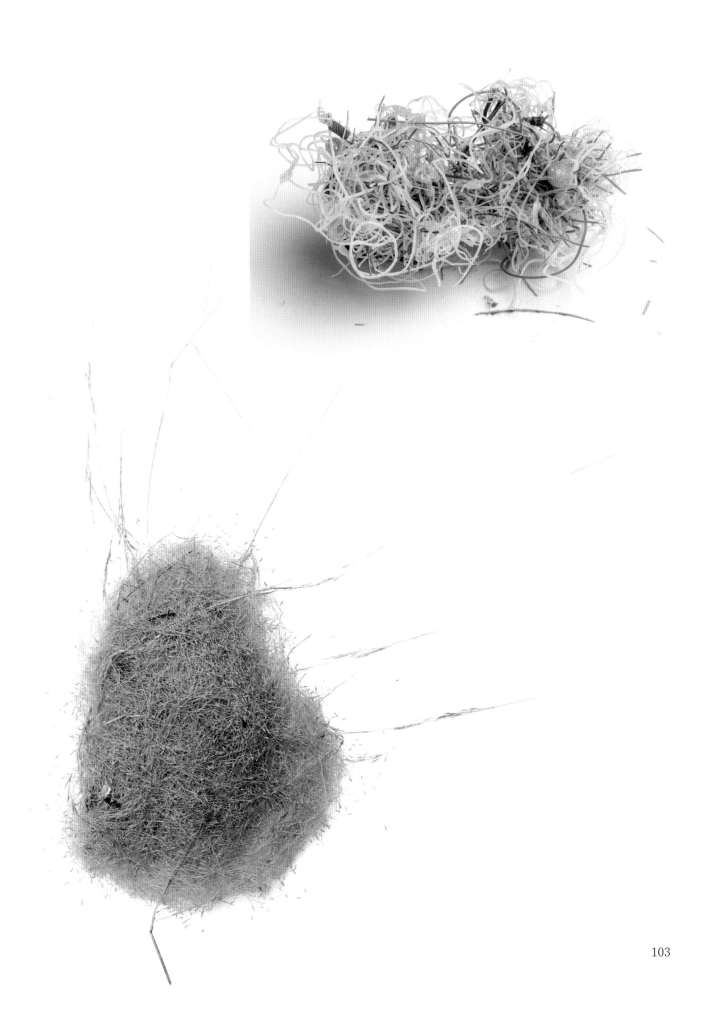

Hidden damage

'I have been sitting with the very low tide edge today as spring equinox reveals that which is usually hidden,' messaged my friend and artist Frances Hatch.

I was also drawn to the result from the severe storms of spring 2022 on my walk above a local beach. Glistening dark tones of seaweed shimmered in the low, early-morning light, and tangled among thick ribbons of kelp were brightly coloured plastic fishing lines.

A few days earlier, on the expansive beach of Woolacombe, I was shocked to see a thick line of tiny pieces of plastic, like beads spilling loose from a long necklace. Picking up a few pieces, I was amazed at the amount unseen from a distance that can accumulate in the hand. I began to check the tide more regularly for pieces to include in my samples and to put into bins. Another woman was doing the same but much more rigorously, explaining she had been picking up rubbish for years. It was good to be reminded of all the unseen actions of people working to tackle the climate crisis, because time is of the essence.

Above: Tide line of plastic on Woolacombe Beach.

Below and opposite: Small pieces of plastic from the beach.

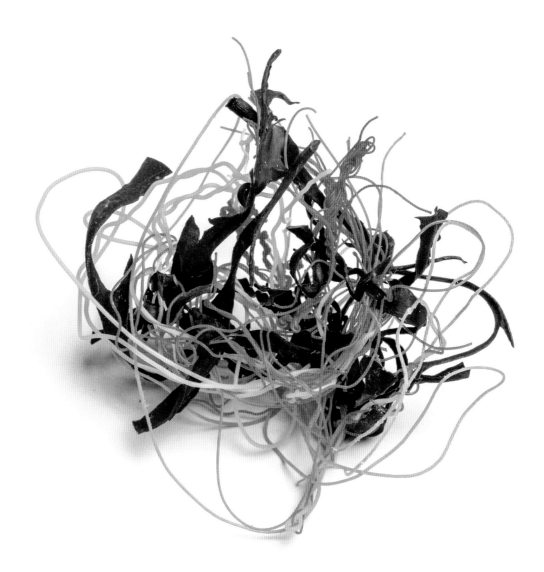

During Easter, I found myself on a typical North Devon narrow lane lined with solid banks of primroses. But this perfect line of yellow was suddenly interrupted by the mass of tangled roots of a tree ripped from the bank by the storms. I had just finished reading *The Hidden Life of Trees* (2015) by Peter Wohlleben, who includes many interesting facts about tree roots and the web of trees' connected community. As I looked into the tangled lines I wondered what creatures and mycelium had been shaken out of this support. I had become aware of the hidden sustaining qualities of nature, and after years of inspiration gained from travelling over land I was now considering the opposite: what I could not see below.

Hidden and healing essence of nature

As I watched the magic of coloured fungi suddenly popping up all over the headland, I was also imagining what was going on below. I was informed by listening to the lyrical voice of Merlin Sheldrake reading his own book about fungi, *Entangled Life* (2020), and explaining the hidden and healing potential of mycelium.

I was delighted by each individual shape, especially early in the morning when they were covered by a tracery of frost, edging and creeping over the form and transforming them into magical sculptures for just a few hours. The transitory and ephemeral in nature is extraordinary. Images can be held permanently in one's memory as it shares its uniqueness so briefly.

Reassurance that I was on the right track came from a visit to the appropriately titled exhibition 'Rooted Beings' at the Wellcome Collection in 2022, a display of work by various artists responding to the symbiotic relationship between plants, fungi and humans.

Frozen fungi.

Right: Broken bank of primroses.

Below right: Exposed tree roots.

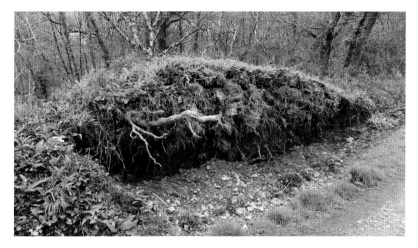

Inspiring statements expanded
my view of the different cultural
concerns with the uprooted.
Michael Marder, for example, states

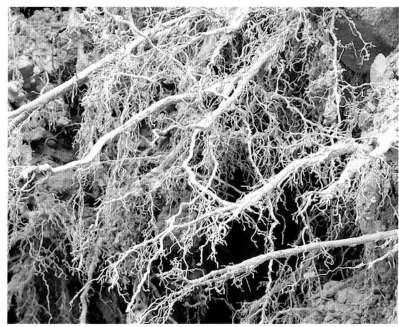

> *'The plant's rootedness in a
> place, their fidelity to the soil, is
> something we can only admire,
> especially because our condition
> is that of an increasing and
> merciless uprooting.'*

A poignant sentiment came from
Davi Kopenawa Yanomami, shaman
and spokesperson for the Yanomami
people in Brazil:

> *'I want to warn the white people before they wind up tearing the sky's roots
> out of the ground.'*

Chilean artist and educator Patricia Domínguez's large installation *Vegetal
Matrix*, with suspended holograms, explored the:

> *'healing practices and the commercialization of wellbeing ... to explore
> narratives of colonial and neo-colonial violence and to honour indigenous
> knowledge on healing and nurturing the living world.'*

It held botanical samples from European and South American collections
at Royal Botanic Gardens, Kew and the Wellcome Collection. The
exhibition images and texts with the artists' various approaches and
perspectives gave me more knowledge and understanding to pursue my
ideas of the hidden and healing aspects of nature further.

Brian Douglas, a mycologist at Kew wrote an article called 'The hidden world of fungi', which gave me an image and purpose to begin sampling:

'Webs of thin threads weaving through soil and organic matter, keeping the world functioning and in balance.'

Considering the healing threads of mycelium and the polluting tangled fishing lines gave me a much-needed prompt to explore stiffening thread into a twisting web. A reel of thin boucle thread (again from my mother's collection) was unwound and painted with diluted PVA glue and laid twisted to dry on a plastic sheet. After gently peeling it off the plastic, I found it was not stiff enough to remain three-dimensional. As it needed to be much firmer, I ordered some stiffener I had used for a previous installation at Salts Mill, Saltaire, West Yorkshire, in 2013.

Stiffened thread.

Threads felted on top of folded book forms.

I had been privileged to participate in 'Cloth and Memory 2' curated by Professor Lesley Millar, where 23 international artists responded to the site of the spinning space at the top of one of the mill buildings. I was in awe of the huge space, where the smell of wool and oil still lingered, but I was drawn to the smaller space of the recesses that held the shuttles. The basic forms I made to fill these spaces were inspired by the two remaining sample books displayed in local museums. The fabric swatches were protected from the light, hidden between paper in large, leather-bound books. But what was revealed was the slippage of coloured threads from the cut edges, curling out between the pages. I was inspired to attach different threads along the top edge of previously made lengths of needlefelts where each thread type spiralled into its own individual form. They were folded into book forms and placed in eight of the bobbin recesses in the exhibition space.

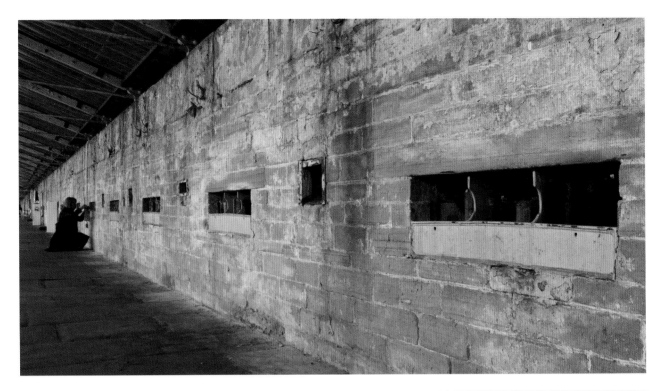

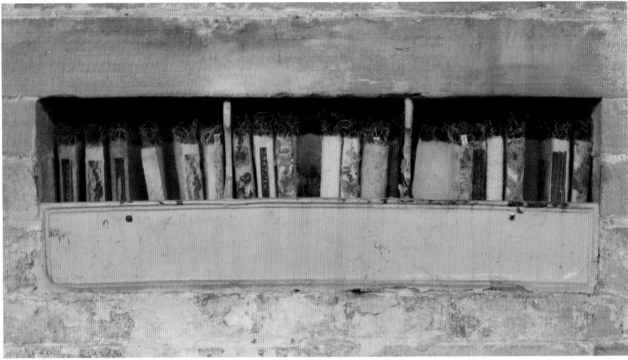

Production Line: People's Lives, *eight recesses,*
31 x 93 x 28cm (12¼ x 36½ x 11in), with individual
works of various sizes from 15 x 5 x 12 (6 x 2 x 4¾in)
to 21 x 10 x 20cm (8¼ x 4 x 8in). Featured in 'Cloth
and Memory 2', Salts Mill, Saltaire, West Yorkshire,
UK (2013). Photographed by Susan Crowe.

Wooden bobbins.

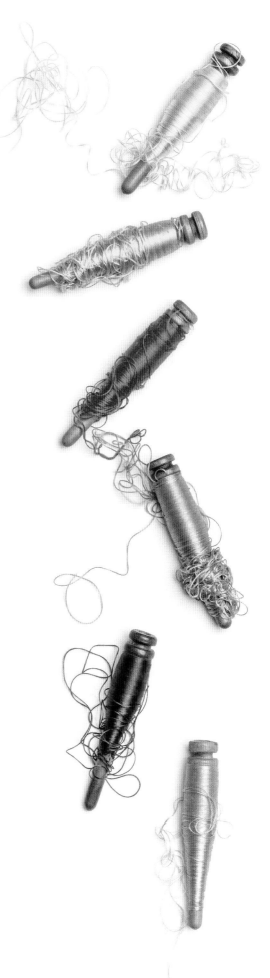

The title 'Cloth and Memory' refers to the powerful emotions that cloth can create on personal memory. In the process of working with the unravelled thread it evoked a childhood memory of visiting a silk-weaving mill where a great uncle worked. He must have noticed my interest as I peered into looms of coloured moving lines, as he gave me some scraps of cloth that had been cut between the lengths. The touch of these loose silk threads and those wound round exquisite, polished, small wooden bobbins were precious objects in my small hands. The bobbins were eventually used hanging on hooks above the Salts installation, bringing them back to their original mill environment. But why had I kept these for 50 years, packed and unpacked through ten home moves? Because they hold something money cannot buy: the moment of being surprised and enthralled at seeing the life of textiles; threads moving, noise and atmosphere, a community working together. This inherited trait confirms why I have to work with textiles rather than paint.

Sampling

The stiffener on the threads was successful, and winding around a tube created tighter curves. A Perspex box was ordered as this would enable the twisting lines below the cloth to be seen from the side. A card prototype was made so I could play freely with various threads and felted samples before the box arrived.

A previously made pre-felt with embedded, dried dandelion seeds seemed appropriate to use, but it needed to become lighter and more transparent to reveal the hidden threads below. The beauty of pre-felts is that they are soft and pliable enough to pull and stretch for a thinner and broken surface.

I chose silk crepeline fabric for a base as it remains transparent and stiff when felted. It is traditionally used in conservation to stabilize and preserve historic fabrics that are weak. Its ability to repair and restore echoes the notion for healing nature: 'can be inserted behind areas of loss and secure with stitches'. An important quality highlighted was 'an inconspicuous interface ... almost invisible', which evoked aspects of the hidden.

 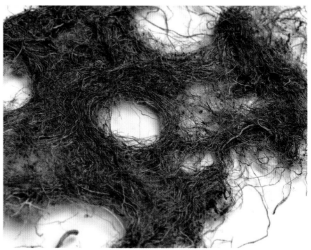

Sample with bonded threads; plant roots.

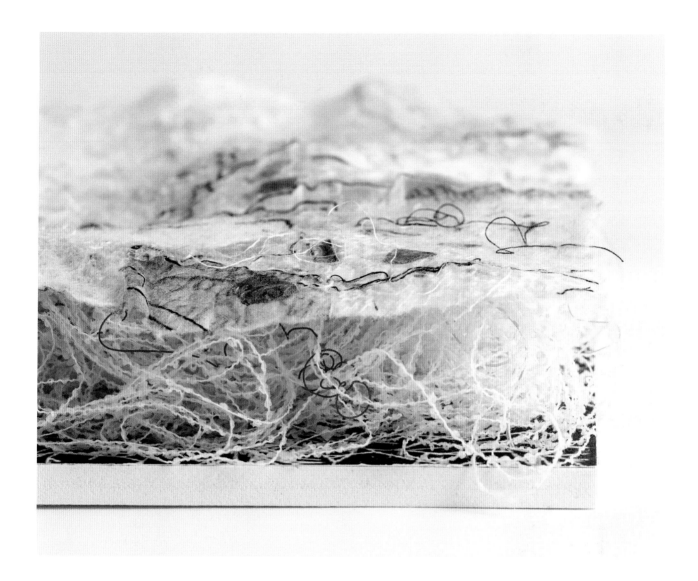

More pre-felts were made with embedded lines of various threads for a structure suggesting hidden mycelium web and tree roots. When the pre-felts were dry and stretched, the threads came to the surface in an organic and haphazard way as in nature.

To convey marks of hidden pollution, a few small pieces of plastic collected from the beach were placed between the transparent cloth and the pre-felt. Stitching around the shapes secured them through the more rigorous final felting process and they were removed once the fabric had adhered to the felt. I also added a few pieces of the plastic fishing line through the twisted thread base. The depth of the clear box sides enabled these to be seen, while the extra light made the material and structure more transparent and fragile-seeming.

Undercover, detail (see also page 118). Photographed by howaboutdave

Nature guides the process

The felted fabric lay well on the stiffened twisted threads, but I needed to make sure they would remain secure once hung on the wall. On the beach the previous week I had discovered a small wooden brush with plastic bristles, an ordinary object transformed by the tide into a fascinating form of tangled lines and seaweed. I noticed how the plastic bristles were attached into the wood, and I tried something similar using short green wires found in my 'bits and pieces' drawer. Bent into a card base they suggested grass stalks and they held the stiffened threads securely with the felt cloth spiked on top. This structure reminded me of sheep's wool caught on barbed wire or on the line of brambles seen the previous month. The feeling of the cloth being caught and trapped was not the effect I had imagined, as it required a floating loose surface.

The next morning, on a new path up a steep hill to the woods, I noticed an area of brambles growing in arched lines. Immediately I realized this shape in wire would hold the form, providing a firm structure to stitch the cloth invisibly onto the top of the arch. This was an example of serendipity, when the unexpected can change the expected, and nature provides a continuous exhibition of forms and colours to inspire and inform.

I needed to find a suitable kind of wire, as all I had were pipe cleaners, which were used for a prototype to judge the size and amount required. I ordered a sample pack of wires online, some of which were covered with cotton or paper that would give a good range to experiment with. When the Perspex box arrived, it was reassuring to place the threads and felt into it, wearing cotton gloves to prevent marking the Perspex surface. I sampled the wires and ordered a pack of the most suitable size to steady the work.

Curving bramble lines (above) and bramble-inspired wire structure (below).

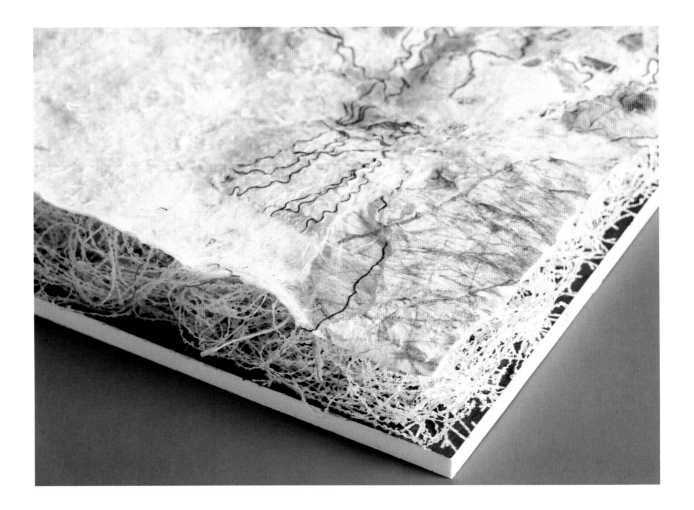

To create a contrast of line to the stitch and threads, I photocopied enlarged details from my hedge drawings onto heat transfer paper, which were later ironed onto the fabric. More felting was required to define the shapes and strengthen the thin structure. The sample was gently agitated on a flat surface with soap and warm water, gradually easing in the cloth to shrink but then stretching it out again to remain thin and transparent. Finally, the soap was rinsed away and the felt laid out to dry, slightly crumpled to give a more organic form.

Alongside the sampling I played with words for a title to express the meaning and feeling of the work. 'Undercover' suddenly popped into my mind on an early-morning walk. This described the structure of the threads 'under' the 'cover' of cloth but also the devious *undercover* tactics used to destroy the rainforest and much more. More words were found for the statement:

> '*The pandemic shifted the focus of Appleton's practice from global travel to local nuances of nature. Allusion is made to the hidden and healing power of plants, from mycelium threads to the scales that bond wool. Polluting materials fused within the form reflect current issues of environmental degradation.*'

Above and opposite: Undercover, *details (see also page 118).*

116

Nature had shown me a way out of a creative block with a new context, fusing thoughts and images as with fibres fused into cloth. Just after completing Undercover, I was astonished to read in his novel *The White Peacock* (1911), D.H. Lawrence's lyrical descriptions of the English countryside, which included his character Lettie describing the protective and healing qualities of nature as a 'care-cloth'. Two of the main characters, who are in love but are betrothed to others, feel strong emotions while under a large tree. Lettie imagines:

> '... the great steel shafts of beech, all rising up to hold an embroidered care-cloth over us; and every thread ... vibrates with music for us, and the little embroidered birds sing; and the hazel-bushes fling green spray around us, and the honeysuckle leans down to pour out scent over us.'

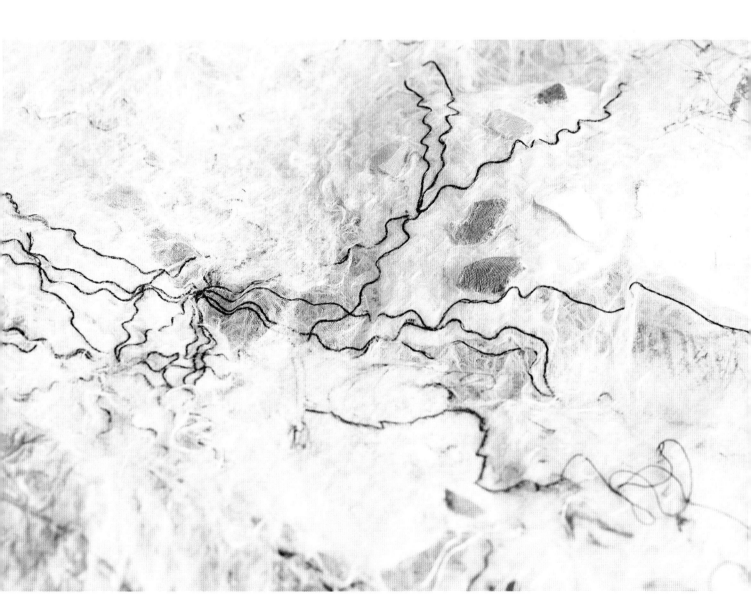

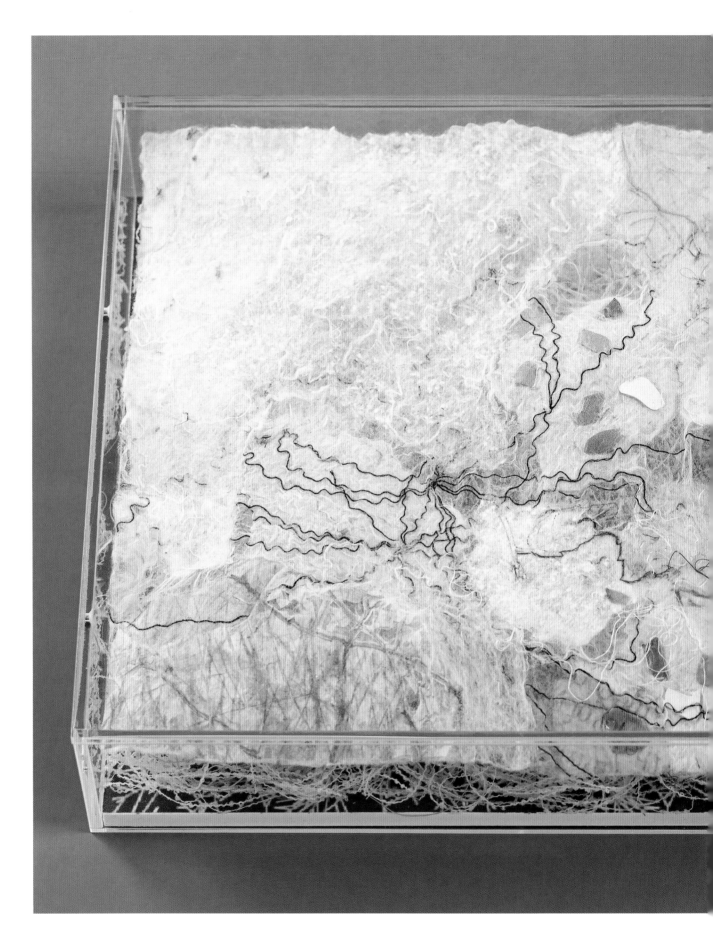

Left: Undercover (2022), 30 x 30 x 7cm (11¾ x 11¾ x 2in). *Stiffened thread, merino wool, silk fabric, thread, heat transfer print and salvaged plastic pieces. Photographed by howaboutdave.*

Right: Canopy of care.

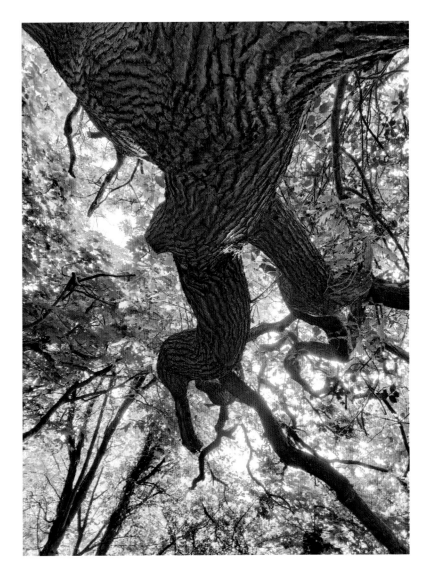

A description inside the cover of *The White Peacock* says that Lawrence 'uses nature to activate our senses and realize its healing powers'. The words reflected the image and meaning of the fragile cloth I had made for *Undercover*. The essence of the care-cloth provided hope and joy, as writer Joelle Georgia describes 'active hope' as doing something, however small, to balance the sense of despair and disillusionment in our lives every day.

> *'When we remember that each of us has a part to play, when we believe that our contribution really does matter, our soul comes alive. We find meaning in a meaningless world.'*

Conclusion

'Be who you are
and say what you feel.
Because those who mind
don't matter and
those who matter
don't mind.'

Dr Seuss, American author and cartoonist

I have been surprised that compiling this book has been a similar process to unraveling the block in my textile practice. I gradually collected fragmented ideas and thoughts that evoked remembered links and associations with past research and project themes. I recognized that words are now just as inspiring as visual images to suggest new ideas for future work. Compiling the photographs from the walked paths and local biosphere emphasized how much they had informed the new work. Subconsciously, I had selected the fragile layered views and forms similar to my work, which has directed a new focus and making process.

Being forced daily into the space of nature has now become part of me, as if a cloak of protection and inspiration covers me. Like that of the nomad warrior whose life is depicted on the Russian Pazyryk felt that lined his tomb in Siberia, my life and journey during the pandemic is preserved and is lining this book.

Opposite: Hold and collect moments – shafts of early light.

Left: Fragile layered view.

It has been a time to appreciate the lifestyle that my thrifty parents showed me, highlighted by the pandemic and the following economic crises to survive everyday practical and emotional needs. These skills are needed more than ever for a creative line of thinking to remain positive through 'life blocks', by appreciating how nature can stabilize uncertainties. A daily connection, even just a few minutes, can release a moment to see and realize the information before you. A shaft of light revealing a shadow, the sound of wind caught in a space, or a smell that triggers a memory from the past. There is a need to hold and collect these moments, to find a word, pick up an object or record the sound and recognize its value for one's personal identity and wellbeing.

After the restrictive years of the pandemic there seemed to be an awakening on the climate crisis and the need for humans to nurture nature. Even in 1962 the ecologist Rachel Carson warned us in her classic book *The Silent Spring* (1962):

> *'The more clearly we can focus on the wonders and realities of the universe about us, the less taste we shall have for the destruction of our race.'*

I made an emotional return to the Netherlands in 2022 to teach my returners at the Hawar Textile Institute and visit my friend and artist Inge Evers after an absence of three years. We explored the new Groote Museum in Amsterdam, which is described as the Museum of Big Questions, considering that 'Everything that lives shares the same home: the world', and placing humans, animals and plants as one. One memorable image was watching the rapid movement of sap in a tree next to the human's very slow blood rate. A poignant sign that seemed to link with ideas I had developed asked a probing question:

> *'Taking Steps.*
> *When we started walking upright, we were still part of the natural equilibrium. The World was at our feet, we went out and made ever deeper tracks with our presence. But now, the earth is threatening to succumb to them. The good news is that you can take new paths. Habits can change … How do we build a new community with the other life on earth?'*

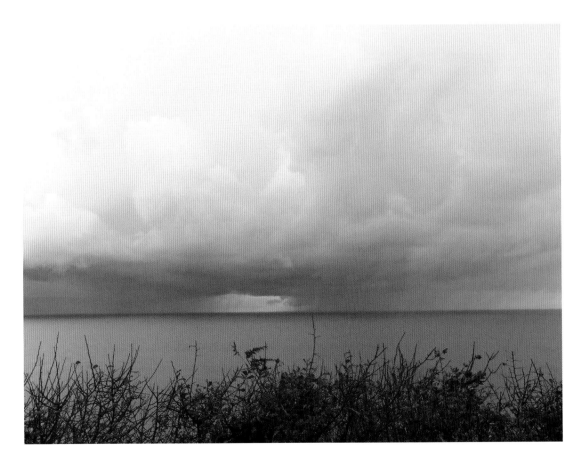

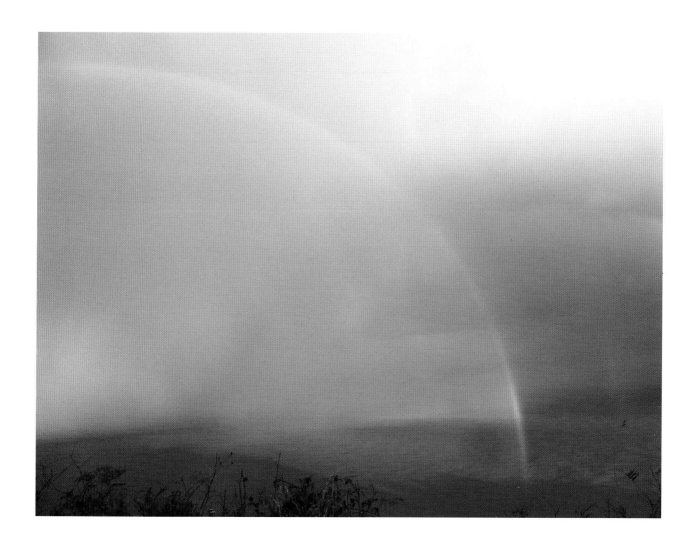

Finding a way to a happy and fulfilling life can be directed by creativity, for a sense of achievement and pride in one's individual self. To follow a route for self-expression and a sustainable lifestyle, with imagination and kindness.

> *'When you do things*
> *from your soul,*
> *you feel a river*
> *moving in you, a joy.'*
> Rumi, Persian poet

A ripple of joy went through me as I watched a line of moody rain clouds on the horizon glide towards me across the sea. Simultaneously, a rainbow gradually began to grow upwards and circle the rain cloud, holding it in its glowing colour. They eventually reached me and I was immersed in this wondrous moment of nature's release. I was grateful for the change of lifestyle to have time to be still and silent and let nature reach into my creative soul.

Above: Immersed in moments of nature's wonder.

Opposite: Horizon line of moody rain clouds.

Sources and bibliography

Bibliography and Further Reading

5 x 15 A World in Transition with Lucy Siegle.

Appleton, Jeanette, 'Felt Crossing Borders: Feltmakers working in Japan'. Embroidery, Vol 54, March 2003, pp10–11.

Bachelard, Garston, *The Poetics of Space* (Beacon Press, 1994)

Berger, John, *G* (Bloomsbury, 1972)

Burkett, ME, *The Art of the Felt Maker* (Abbot Hall Gallery, 1979)

Carson, Rachel, *The Silent Spring* (Penguin Modern Classics, first published 1962)

Common Ground, *A Manifesto for Fields*, 1997, manifesto 41.

Dominguez, Patricia, *Vegetal Matrix*, 2021, exhibition guide as part of Rooted Beings exhibition 2022.

Douglas, Brian, mycologist at Kew Gardens, https://www.kew.org/read-and-watch/the-hidden-world-of-fungi.

Eiseman, Leatrice, *Agnes Martin's Palette*, Tate Research Publication, 2015

Gergis, Joelle, *Humanity's Moment: A Climate Scientist's Case for Hope* (Black Inc., 2022)

Guigova, Rozaliya, Contemporary Research on the White Cloth as a Ritual Item in the Bulgarian Wedding: Anthropological Approach. https://www.researchgate.net/profile/Rozaliya-Guigova.

Haskell, Barbara, *Agnes Martin*, Whitney Museum of American Art, 1993

Hunter, Clare, *Threads of Life* (Sceptre, 2020)

Ingold, Tim, *Lines: A Brief History* (Routledge, 2016)

Kim, Jeeun, The Usage and Symbolic Meaning of a Length of White Cloth Used in Shamanistic Rituals for the Dead in Korea. https://www.researchgate.net/publication/265083924

Kumar, Satish, Indian British activist and speaker, Editor Emeritus of *Resurgence* and *Ecologist* magazine.

Lawrence, DH, *The White Peacock* (William Heineman, 1911)

Malouf, David, *The Great World*, Pan Macmillan, 1991.

Marder, Michael, Ikerbasque Research Professor of Philosophy, University of the Basque Country UPV-EHU, Vitoria-Gasteiz and Davi Kopenawa Yanonami, shaman and spokesperson for the Yanomami people in Brazil are both quoted by curator Barbara Rodriguez Munoz in her essay in the introduction of the Rooted Beings exhibition catalogue, The Wellcome Trust, 2022.

Davis, Martin, 'The Conjuror's Bird'. Hodder & Stoughton (2005)

Michaels, Anne, *Fugitive Pieces* (Bloomsbury, 1996)

Morris, Robert, Recent Felt Pieces and Drawings, Henry Moore Sculpture Trust, Leeds, 1996–7, https://webarchive.henry-moore.org/hmi/exhibitions/past-exhibitions/1997/robert-morris-recent-felt-pieces-and-drawings; https://www.tate.org.uk/art/artists/robert-morris-1669.

Sahota, Sunjeev, *China Room* (Random House, 2021)

Sheldrake, Merlin, *Entangled Life* (Random House, 2020)

Solnit, Rebecca, *Wanderlust: A History of Walking* (Verso, 2001)

Wohlleben, Peter, *The Hidden Life of Trees* (HarperCollins, 2017)

Museums and Exhibitions

Cloth & Memory II (2013)
Curated by Professor Lesley Millar at Salts Mill, Saltaire, Yorkshire
www.clothandmemory.com https://transitionandinfluence.com/cloth-and-memory.

Through The Surface touring exhibition (2004)
www.throughthesurface.com.
Land x Line: Double-Edged Encounters purchased by the Contemporary Art Society for the permanent textile collection at Nottingham Castle Museum and Art Gallery. Featured in *revealed* catalogue published by Nottingham City Museums and Galleries, 2005.

Groote Museum, Amserdam
www.grootemuseum.nl/nl.

Louise Bourgeois exhibition Woven Child (2022)
Hayward Gallery, London

'Museum of the Moon' installation (2021)
Exeter Cathedral

The Wellcome Collection
The Wellcome Collection in London is a free museum and library exploring health and human experience. Their exhibitions connecting science, medicine, life and art challenge how we feel about health.

Suppliers

Hemp thread (5cm)
Organic Cotton Plus (www.organiccottonplus.com)

Hortiwool
www.hortiwool.com

Merino wool
adelaidewalker.co.uk
winghamwoolwork.co.uk
worldofwool.co.uk
Consider sample packs and pre-felt.

Open-weave fabric
Look in charity shops for scarves, threads
and more. Enjoy the surprises and work
with the discoveries!

Perspex boxes
displaysuk.co.uk
(I used the wall-mounted acrylic display case)

Silk crepeline fabric
restore-products.co.uk
whaleys-bradford.ltd.uk

Silk paper yarn
Habu Textiles (habutextiles.com)

Stiffener
Powertex Transparent Fabric Hardener,
available from powertex.co.uk

*Please note that the needlefelt machine is no
longer available at Huddersfield University.*

Index

Ambrose, Michael 85
Appleton, Jeanette
 childhood 20, 44, 48, 79, 89, 97, 99, 111
 mother 36, 57, 61
 residencies 15, 18, 22, 24, 85
 thinking/making 97
archives 7, 91, 92, 111
Armitage, Simon 57
art education 20
'Art Textiles II' exhibition 65
Australia 16, 17, 58, 60, 69, 76, 102
awns 100

Bachelard, Garston 14
barns 89, 98, 99
beauty 29
Berger, John 37
Biosphere Reserve 25
bonding 97, 100, 102
books, folding 17, 18
boro mending 72–3
Bourgeois, Louise 56, 57, 74
brambles 114, 115
brushes 114
Bulgaria 59

Carson, Rachel 121
Cézanne, Paul 98
Changing Currents: Challenging
 Changes 2–3, 28, 40–3
chiffon 60
climate crisis 11, 63, 65, 69, 97
cloth see also needlefelting
 cutting 65–6, 68
 literature 86
 memory 56–8, 61, 70, 111
 protection 24, 76–7, 85, 92, 117
 transformation 60
 white 59–60, 66
'Cloth and Memory 2' exhibition
 109, 110, 111
cobwebs 11, 32
collaboration 84–5
collage 71
Common Ground 48
contemplation 29–30, 91
Coomaraswamy, Ananda 26
coral 94, 95
Covid 19 pandemic
 constraints in creativity 17–18
 lockdown 7–8, 11, 15, 84, 121
 loss 86
 messages and memorials 8, 9, 79
 wellbeing and open space 25, 49
 creative blocks 11, 15, 117, 121

Crowe, Victoria 16
cutting 65–6, 68, 70

dandelions 13
darning 75
Davis, Martin 86
Desire Lines 52–5
dew 11, 37
dialogue 84–5
diaries 12, 27
Domínguez, Patricia 107
Douglas, Brian 108
Dry Drifting Shadows: Alpujarras
 32, 33
dyslexia 20, 79

edges 70–1
education 20
embroidery 19, 58, 77, 86 see also
 stitching
Emerson, Ralph Waldo 30
emotions 75, 80
environment
 engagement with 7–8, 11
 historical layers 25–6, 70
 language 66, 80
'Essence' 99
Evers, Inge 122
Exeter Cathedral 96

fabric see cloth
Fast Fashion Costs the Earth 63, 69
Felt Crossing Borders project 84
felting see also needlefelting; pre-
 felts
 bonding 97
 cutting 66, 68
 lace 63, 65, 92, 94–5
 natural interlocking 4, 102, 103
 nomads 48, 76, 99, 121
 Russian rugs 72, 121
 shibori 84, 85
 textures and transformation 60, 85
 fossils 26, 96
 frost 11, 30, 76, 106
 fungi 30, 31, 106, 108

Georgia, Joelle 119
Georgia, Republic of 16, 22, 77
Giacometti, Alberto 99
grasses 4, 46, 47, 48, 52, 55, 102, 103
Guigova, Rozaliya 59

Haigh, Janet 75
haikus 80–1, 82
Harrison, George 6

Hatch, Frances 49, 104
healing 97, 117, 119
Hedge Edges Between 45
hedges 44–5
hidden inspiration 99–106, 112, 116
history 25–6, 29, 70, 72–3, 77
Hooper, Max 44
Hortiwool 76
Huddersfield, University of 18, 24,
 76, 85
humans, place in the land 25–6, 69
Hunter, Clare 77
Hvistendahl, May Jacobsen 84

ideas, collecting and evolution
 91–3, 96–7
Ilfracombe 21
imagination 48, 91
indigenous people 83, 107
Ingold, Time 58, 69
interruptions 93

Japan 16, 17, 72–4, 76, 84
Jeneid, Liz 60
John Innes Institute, Norwich 24,
 25, 76, 85, 92
Johnson, Jorie 84
journeys 7–8, 11, 17, 18, 97

Kandinsky, Wassily 37
Kavanagh, Patrick 11
Kim, Jeeun 59
Klee, Paul 29
Korea 59
Kumar, Satish 95

lace 63, 65, 92, 94–5
land
 commodification 58
 humans 25–6, 69
 protection 77
 salinization 60
Land Line: Double Edged
 Encounters 18, 19
landslides 77
language
 memory 82, 83
 nature 80
Lawrence, D. H. 117, 119
leaves 4, 37
lines see also stitching
 delicate 92–3
 essence of nature 29
 floating 32–5
 journeys 17, 18
 nature 37, 41–2, 44–6, 47, 48, 52, 104

restrictions 22–3
sentences 87
threads in felting 26, 39, 52–5, 113, 128
literature 86–7
Lockdown sketchbook 27
Long, Richard 49
'Loose Threads' exhibition 32

Mairet, Ethel 26, 96
Malouf, David 29
maps 16, 21–2, 24, 49, 50
Marder, Michael 107
Martin, Agnes 28, 29
Mason, Dawn 75
meditation 30
memorials 79
memory
cloth 56–8, 61, 70, 86, 111
creative process 89, 121
language 82, 83
mending 72–3, 74, 75
'Mending at the Museum' exhibition 75
Michaels, Anne 86
Millar, Lesley 18, 109
Mongolia 48, 76, 99
Morris, Robert 65
mycelium 105, 106, 108, 113, 116

Nant Mill Visitor Centre, Wales 15
National Geographic 61
nature
healing 97, 117, 119
hidden inspiration 99–106, 116, 123
immersion 12, 38
language 80
wellbeing 25, 49, 87
needlefelting 18, 19, 34, 76
needles 29
Netherlands 122
nettles 29
Nielsen, Lene 48, 84
'No Mow May' 55
Nomad: The Red Line of Danger 22–3, 35
nomads 48, 76, 99, 121
Norway 76

O'Keefe, Georgia 89
Oliver, Mary 10, 46

patching 72–3
plague 57
plants
awns 100
fibre 102
healing 97
mutant 34
protection 24, 76, 76, 85, 92
plastic 104, 105, 113

play 45, 91, 97
pre-felts 36, 112–13
Production Line: People's Lives 109–10
projects
forgotten 7
timescales 17, 93
protection 24, 76–7, 85, 92, 117
proverbs 64

Raedecker, Michael 32, 35
rainbows 8, 9, 123
re-wilding 45
'Red' exhibition 22
refugees 22
restrictions 11, 121
Rilke, Rainer Maria 88
risk 91
rituals 59
rivers 61
'Rooted Beings' exhibition 106–7
roots 105, 107, 113
On Route: In Root 24–5
Rumi 123
Russian rugs 72, 121

Sahota, Sunjeev 86
salinization 60
Salts Mill, Saltaire 108–9, 110
sashiko 73
scales 100, 102, 116
scarves 56, 57–8, 71
sea 41–2, 104
sequences 85
Seuss, Dr. 120
'Sew:Sow' exhibition 34
Sheldrake, Merlin 106
shibori 84, 85
silk crepeline 112
sketchbooks 7, 14, 15–17, 18–19, 20, 27, 50–1
Sketches: The Sun That Divides 58
slits 65–6
soil 50
Solnit, Rebecca 78, 87
source material selection 91–2
souvenirs 57
Spain 24, 32, 77
spatial awareness 21–2
steps 21, 122
stiffener 108, 112
Stitch and Think project 75
stitching
collage 71
displacement activity 37, 38
into felt 38–9
literature 86
rhythm and walking 58
sashiko 73
sketches 36
visual language 75

stones 79, 83, 96
storms 104, 105
sustainability 80, 99, 123
symbolism 59
synthetic cloth 60

Tardieu, Jean 7
textiles see cloth
thinking time 97
threads see also stitching
forms 33
history 29
lines in felting 26, 39, 52–5, 113, 128
nature 38
stiffening 108, 112
storage 33
unattached 32
'Through the Surface' exhibition 18, 19
tide lines 41–2, 104
Tracks and Traces: Alpujarras 71
travelling see journeys
trees 37, 105, 122

uncertainty 36, 75, 121
Undercover 113, 116, 117, 118–19

van Gogh, Vincent 40
Veiled Land: Coded Site 64–5, 66–7
video 23

Wahl, Jean 44
walking 7–8, 11, 17, 21, 25, 50–1, 52, 78
weaving 26
webs 92, 108
weddings 59
wellbeing 25, 49, 91, 107, 121, 123
Wellcome Collection 106–7
white cloth 59–60, 66
Wohlleben, Peter 105
wool 60, 76 see also felting
words see also language
indigenous people 83
inspiration 121
literature 86–7
messages and memorials 79
'Woven Child' exhibition 57

Yanomami, Davi Kopenawa 107
yurts 76, 99

Acknowledgements

Thanks to my grandparents, James and Freda Willis, and my parents, Ron and Tilly Campbell, who taught me to live sustainably and respect nature. Thanks to my daughter Zoe and grandson Isaac, who joined many walks and offered support during the pandemic.

My archive has been accumulated through years of exploration with support and encouragement from family and friends, colleagues and participants, workshop hosts and organizers, curators and mentors, universities and funders – an endless list.

Many thanks to the excellent team at Batsford for compiling my meandering ideas so succinctly into a coherent form. Unless otherwise stated, all photography is by Michael Wicks, with the exception of photography by the author on pages 6, 7, 8, 9, 11, 12, 13, 15, 21, 25 (bottom left), 29, 30, 31, 32 (bottom), 33 (bottom), 37, 38, 44, 46, 47, 48, 49 (bottom), 63, 72, 76, 77, 78, 79, 84, 87 (top), 92, 93, 96, 97 (bottom), 104 (top), 105 (bottom), 106, 107, 110, 115 (top), 119, 120, 121, 122, 123.

Below: Embedded and surface lines with different threads, detail.